THE
WHOLE
WOMAN

editors
KRISTIN L. KELLEN and JULIA B. HIGGINS

THE WHOLE WOMAN

MINISTERING TO HER HEART, SOUL,
MIND, AND STRENGTH

B&H
PUBLISHING
NASHVILLE, TENNESSEE

DEDICATION

To my grandmother, a wise and joyous
woman who loved us wholeheartedly.
—KK

To my husband, for his encouragement and
insight, and most of all, his love

and

To my mother, whose example inspires me
to minister to the whole woman.
—JH

CONTENTS

INTRODUCTION

What images come to mind when you think about ministry to other women? Perhaps a women's Bible study, a regular lunch gathering, or a meal train after a birth or surgery? All of these are good, of course. But *why* do we do ministry that way? Is it simply because that's the way it's always been done?

The aim of this book is to explore how we *should* be ministering to our sisters in Christ, flowing out of the great command in Mark 12:29–31:

> Jesus answered, "The most important
> [commandment] is Listen, Israel!
> The Lord our God, the Lord is one.
> Love the Lord your God
> with all your heart, with all your soul, with all
> your mind, and with all your strength.
> The second is, Love your neighbor as yourself.
> There is no other command greater than these."

In short, we are to love God with all of our being: heart, soul, mind, and strength. Then we love those around us as an outpouring of our love for God. Part of that love for our neighbors is to

help them love God more fully, to help them obey these same commands.

This book walks through the four areas of love for God (heart, soul, mind, and strength), not just examining what those mean for us as *we* love Him, but how we can minister to other women specifically in those areas as well in order that they might love God more holistically. We'll look at what the Bible has to say about topics like our emotions, our thoughts, our bodies, and others, as well as some common areas of struggle within each of those realms. Our hope, friend, is that you will be encouraged both in your own walk with the Lord in those areas as well as how you might minister to those around you more intentionally.

Additionally, we've included some questions for reflection at the end of each chapter. You might use these personally in your own study (we encourage journaling!), or you might get together with a group of ladies and discuss the questions together. They are there for further encouragement and to build you up (1 Thess. 5:11).

Finally, you'll notice that this book is written by a number of contributors. Each of these ladies intentionally ministers to the women around them, setting wonderful examples of those we can emulate (1 Cor. 11:1). They love the Lord passionately, and they strongly desire to see others know and love Him too. We believe God has gifted each of them with a deep love for ministering to women, and we're excited to share that love with you.

We're thrilled to remind you of these truths from God's Word as you journey toward a deeper love for Him and His people! May the words that follow encourage you, strengthen you, and spur you on toward greater love for our Father and for your sisters in Christ!

—Kristin L. Kellen and Julia B. Higgins

1

BIBLICAL WOMANHOOD

Julia B. Higgins

Then the LORD God said, "It is not good
for the man to be alone. I will make a
helper corresponding to him."

—GENESIS 2:18

Introduction

Have you ever tried to define the phrase "biblical woman-hood"? It's a term Christian women hear often, but when pressed, would most of us know how to define it? And beyond just defining the term, would we know what it means to *be* a biblical woman? To understand who we are at our core? Sure, we may hear a lot of conversation around the various *roles* women play within biblical womanhood as well as the various *functions* they fulfill in the realms of home, church, the workplace, society, and so on. And

those conversations are important. Yet a woman is more than her role or function even though definitions of biblical womanhood are often limited to such.

To better understand ourselves as women, however, we shouldn't start with roles or functions, important as they may be. We should first zoom out to describe a woman's *nature*—as one who is created, who is a sinner, who is redeemable, and who may be restored. Thus, a biblical woman is one who is *created by God, whose fallen nature is redeemed by Christ, and who is being restored to love God with her whole heart, soul, mind, and strength.*

You might wonder: *Isn't this simply the definition of a biblical follower of Jesus, male or female?* And that is a fair enough question. But in many circles this broader description is typically left either unexplored or undefined altogether. We can, in all our efforts to follow God's specific instructions in our womanhood, miss the greater picture of what the Bible says about who we are as female followers of Christ. In all our dedication to the details, we forget to let the Bible paint the broad brushstrokes of what is true about us on the whole, so this definition helps us think toward that end.

Bearing that definition in mind, in this chapter we will discuss the nature of our Creator God, the concept of humans being made in His image, as well as the implications of this truth for a woman's life. We will consider the impact of sin and how the image of God has been marred in women, reflecting on the impact of sin's curse. But we won't stop with the bad news! Ultimately, we will rejoice in the life-giving hope predicted in Genesis 3 for

all mankind, irrespective of gender, and that women may be made partakers of eternal life through the gospel of Jesus. The chapter concludes by examining the trajectory of biblical womanhood—that of being restored to love God with our whole heart, soul, mind, and strength.

The Creator

The first book of the Bible is aptly named Genesis, which literally means "origin." The book gives us the origin of the world and everything in it, including the beginning of humankind with the first couple created by God. Adam and Eve, who were both created in the image of God, were made to reflect God's character and nature. It is helpful, then, to consider the character and nature of God. We cannot understand how to reflect Him if we do not study Him, and in understanding His nature, we begin to understand ours.

Chapter 1 of Genesis reveals many acts of God that display His character and nature: He is all-powerful, literally creating the entire universe out of nothing (v. 1), He speaks and light comes into existence (v. 3), He names day and night (v. 5), He creates an expanse and separates "the water under the expanse from the water above the expanse," giving the expanse a name: heaven (vv. 6–8). He gathers the waters on the earth and allows the dry land to appear, naming the dry land "earth" and the gathered waters "seas" (vv. 9–10). He brings forth vegetables, plants, and fruit (vv. 11–12); He creates the sun, moon, and stars and establishes

seasons, days, and years (vv. 14–19). He makes sea creatures and birds, blessing the creatures and birds with an admonition to multiply (vv. 20–23). He forms all living creatures, including livestock, creeping things, and beasts (vv. 24–25).

God's actions in Genesis 1 reveal to us that He is holy, all-powerful, and in control. God demonstrates His holiness as Creator when He creates all things in His created order as perfect and "good." When God creates the universe out of nothing, when He speaks light into existence, and when He names day and night, God exhibits His power over all things as well as His right to do with His creation whatever He finds pleasing. These characteristics are attributes that God does not share with human beings: they are "incommunicable attributes" (meaning they are unique to God alone and do not fully transfer to humans made in His image). For example, we have *some* jurisdiction over spheres in our life that God gives us authority over, but we do not have *total* jurisdiction and power over the entire earth in the way He does. Though these attributes are not fully shared with human beings, both men and women are created to image these attributes, albeit in a limited way, in the world today.

The Created

The first mention of a female in the Bible denotes the primary lens through which women should be viewed: as creatures made by God in His image (the *imago Dei*) who are distinct from men. Genesis 1:27 states that "God created man in his own image;

he created him in the image of God; he created them male and female." The description found in Genesis 1:27 of God's creating man and woman in His image is a response to the preceding verse, which describes the declaration of our triune God: "Let us make man in our image, according to our likeness. They will rule the fish of the sea, the birds of the sky, the livestock, the whole earth, and the creatures that crawl on the earth" (Gen. 1:26). Notice what is said about man and woman in these verses: first, humans are made after the image or likeness of God, and second, God gives them dominion over created animals such as fish, birds, livestock, and over every creeping thing, as well as over all the earth. Both genders are created in God's image, and both are given dominion over the earth. Men and women alike are created with a common purpose: to reflect the Lord in exercising dominion over the entire earth through being fruitful and multiplying, filling the earth and subduing it.

But how are women to join men in exercising dominion over the earth? This concept is further unpacked in Genesis 2. In the first half of Genesis 2, a longer description of the creation of Adam is given, culminating with verse 15: "The LORD God took the man and placed him in the garden of Eden to work it and watch over it." The functional purpose God gives to Adam corresponds with the functional purpose for man and woman found in Genesis 1:27: they are to rule over and cultivate the entire earth. Genesis 2 reveals that God created Adam first, and yet it was "not good" that he was created alone. He was incomplete and without a "helper corresponding to him" (v. 18). The *ESV Study Bible*

notes that the Hebrew word for "helper" reveals Adam needed someone "who supplies strength in the area that is lacking in 'the helped.'"[1] Adam could not obey the command of God to be fruitful, multiply, and fill the earth without the complementary help of Eve. Adam and Eve *together* illustrate the perfect union of man and woman created in God's image to carry out the divine mandate to rule and reign, as delegated to them by their Creator God.

The creation account provides us with an understanding that man and woman are designed to obey the Lord in a partnership that glorifies God and is good. A biblical woman comprehends that her role as woman is to image God and partner with man in obeying God's commands for His glory. She is first and foremost aware that her Creator God is the supreme ruler over all the earth, which includes her, and therefore He is the one who has total authority over her life. Though He has assigned jurisdiction and responsibility to her, it's a *delegated* responsibility, and she gives an account to God for how she handles it. In other words, she must answer to God and obey Him because He's the one in control. On top of this, she realizes that God has given her a particular way to express her nature, as "helper"—complementing Adam, and alongside him, reflecting God's image. (This does not mean, of course, that a woman can only reflect God's image if she is married, or that she cannot bear God's image apart from a man, for God has created *both* men and women in His likeness.) Genesis 2 does not provide an exhaustive list of what Eve's help would look

[1] *The ESV Study Bible* (Wheaton, IL: Crossway, 2018).

like for Adam. Surely it plays out in a myriad of ways within various contexts. But we do know that Adam cannot work the garden, keep it, multiply throughout the earth, and rule everything that needs ruling alone. This then leads to the knowledge that women have been provided by the Lord to bring forth a God-honoring society in partnership with men.

Fallen

The impact of sin is not difficult to ascertain. Preachers often joke that to prove the sin nature present in every human, you don't have to look any further than a church nursery full of young toddlers, who all scream "Mine!" as they fight over the same toy. However, we can look at any demographic of the church to see that the sin nature is alive and well. Women (as well as men and children) break the law of God on a daily basis. We fail to meet the righteous requirements set forth in the Ten Commandments given to Moses so long ago. We believe lies, and we speak lies; we covet our neighbor's goods, and we love idols more than we love God. Theses sins which easily entangle all of us stem from the first fall into sin committed by Adam and Eve in the garden.

In Genesis 2, God gives Adam the command not to eat of any fruit from the tree of the knowledge of good and evil, with the clear warning that if he eats from it, he will die. Many theologians maintain that this command was given to Adam before Eve was created, signifying that the man was given the role of leadership, being held ultimately responsible for whether mankind heeded this warning.

After the command is given to Adam, we read the Lord's comment that it is not good for Adam to be alone, which leads the Creator to make a "helper corresponding to him." The chapter ends with the Lord creating woman as an equal image bearer, from Adam's side, wherein Adam and Eve become one flesh.

Genesis 3 recounts the fall of both Adam and Eve into sin, as accomplished through the crafty work of the serpent. The serpent subverts God's plan of male headship in marriage by approaching Eve and calling God's word to Adam into question. The text does not state that Adam told Eve the command of the Lord not to eat of the fruit from the tree of the knowledge of good and evil, but Eve recounts an incorrect version of the command to the serpent, so we can assume Adam told Eve the Lord's instructions. The text tells us that Eve was tempted by the food, found the food delightful to look upon, and that she desired to be made wise by eating the fruit. She follows the pattern shown in James 1:15 (where the conception of desire results in sin) and so was deceived and became a transgressor (1 Tim. 2:14). Adam, standing beside her, took the fruit she offered to him (Gen. 3:6) and through his actions brought sin into the world, death through sin, and the spread of death and condemnation for all men (Rom. 5:12, 18).

The effects of sin are immediately seen as Adam and Eve fearfully hide themselves from the presence of God. When they are confronted, they begin shifting blame. The resulting consequence for Eve's sin is pain in bearing and delivering children, as well as desire for her husband and his ruling over her (Gen. 3:16). The Hebrew phrase that is often translated "your desire will be

for your husband" has been debated throughout the years with many suggested meanings that the scope of this chapter cannot provide. However, the main concept to understand about Eve's fallen nature (and the resulting impact on all women) is that sin and the Fall introduced hardship in at least two areas of a woman's life: childbirth and marriage. In order to fully understand womanhood, we need to comprehend a woman's nature as being made in the image of God and equal with Adam, yes. But because of the fall, we also need to understand that she is fallen in her humanity, at enmity with God, in discord with her husband, and in physical pain when she bears children.

Redeemed

While God assigned painful consequences for sin in the lives of women, His words were not without grace. The verse preceding Genesis 3:16's curse upon women includes within it the hope of eternal life. In fact, Genesis 3:15 has been called the *protoevangelium,* which means "first gospel" or rather the first announcement of the gospel. The Lord promises one to come through the woman's offspring. The serpent is told that though he will bruise the offspring's heel, ultimately the offspring will inflict a more fatal blow: he'll bruise the serpent's head. This statement is good news because it foreshadows the destruction of the devil by the victorious work of Jesus Christ.

Genesis 3:15 is one of the foundational verses of the entire Bible, as the narrative then begins to unfold with humankind

waiting on this promised One who will bring victory over sin and the devil. Commenting on the importance of Genesis 3:15, Sinclair Ferguson, a well-known preacher and theologian, has famously said that in the same way that Western civilization is but a footnote to Plato and Aristotle, so all of the Bible is but a footnote to Genesis 3:15.[2] Thus, we see throughout the Old Testament continued promises for the One who will bring rest from sin to the people of God as their prophet, priest, and king. And then moving into the New Testament, we see the same themes as Jesus Christ is born and fulfills the longing for rest and who serves humankind as our Prophet, Priest, and King.

The need for rest from sin is seen in Genesis 3:21 where the Lord acts as a priest on behalf of Adam and Eve by providing clothing or "garments of skin." The clothing is a symbol of God's grace as He covers the shame of the couple's nakedness, and the allusion to animal sacrifice points to the blood sacrifices required under the Mosaic law to make payment for sin, a ceremonial process that could only be enacted by a priest. Thus, we see the God of the universe provided a means to cover the guilt and shame that Adam and Eve experienced and worked on their behalf to bring them back into fellowship with Him. The active work of God to bring salvation to His people is ultimately fulfilled in the blood sacrifice of God's beloved Son, Jesus.

[2] Sinclair Ferguson, "Preaching Christ from the Old Testament," Truth for Life, May 10, 2010, https://www.truthforlife.org/resources/sermon/preaching -christ-old-testament.

Throughout the Old Testaments, we find allusions to a greater prophet, priest, and king. A greater prophet is promised to Moses when the Lord tells him in Deuteronomy 18:18: "I will raise up for them a prophet like you from among their brothers. I will put my words in his mouth, and he will tell them everything I command him." A greater priest is prophesied in Psalm 110:4 as the psalmist contends that the Messiah will be "a priest forever according to the pattern of Melchizedek." A greater king is promised to come from the tribe of Judah: "The scepter will not depart from Judah or the staff from between his feet until he whose right it is comes and the obedience of the peoples belongs to him" (Gen. 49:10). This same king is also promised to come from the line of King David: "When your time comes and you rest with your ancestors, I will raise up after you your descendant, who will come from your body, and I will establish his kingdom. He is the one who will build a house for my name, and I will establish the throne of his kingdom forever" (2 Sam. 7:12–13).

What do the promises of rest and the coming prophet, priest, and king have to do with women today? As women corrupted by sin, fallen in our nature, and at enmity with God and with other people in our lives, we desperately need rest from our sin. We need a prophet who speaks God's Word to us and reveals God's will, a priest who atones for our sins and intercedes on our behalf before a righteous and holy God, and a king to whom we submit our lives. When we look at the options that have come before Christ, we are sorely disappointed. But when we look at Jesus, we see that He is the truer and better fulfillment of all of these

offices. In fact, Jesus doesn't just speak God's Word to us; He *is* the Word. He doesn't enact an atonement ceremony as an ordinary priest handling a sacrifice; He *is* our atoning sacrifice. And He doesn't know of some temporary king we could follow for a short span; He *is* the eternal king of the universe. The Bible makes clear that Jesus Christ is our promised rest; He is our ultimate Prophet, Priest, and King.

How can women know this Prophet, Priest, and King? Through the work of the Holy Spirit, we come to the understanding that we are incapable of obeying all of God's commands, as the Bible teaches us "there is no one righteous, not even one" (Rom. 3:10). The conviction of sin then leads to remorse and repentance, a turning away from disobeying God and His law and a turning toward God for hope. Our hope is cast on Jesus. We begin to recognize that only Jesus has been perfect in our place. Only He has pleased God. And we come to accept that Jesus took upon Himself, on the cross, the punishment for our sin. This sacrifice satisfied God's wrath. When we repent from our sin and place our faith in the finished work of Jesus, the Lord saves us by His grace and mercy alone. Salvation then leads the created, yet fallen, woman to true biblical womanhood as she begins to be restored to love and serve God with her whole heart, mind, soul, and strength. In short, a biblical woman responds to God's salvation by serving Him with each part of her being that was redeemed, which is *every* part. Because Jesus saved every square inch of her, she now serves Him with every one of those square inches.

Restored

In the life of the redeemed, the Lord begins the work of restoration. Now restoration sounds wonderful, but what exactly is the *point* of the Father's restoration? In the life of Eve, the beginning of her restoration was in Genesis 3:20, when Adam "named his wife Eve because she was the mother of all the living." After their fall into sin, the curses were given, and all hope seemed lost, Adam called the woman by her new name, illustrating his hope in God's promise of the offspring she would have that would bring victory over Satan. This new name brought with it a reminder back to the command of Genesis 1:27–28 for Adam and Eve to "be fruitful, multiply, fill the earth." While Eve (and Adam) had committed a grave sin, through the Lord's promises and provisions, woman was given the encouraging knowledge that she would be able to accomplish that for which she was made. Though she had just sinned, God still had a name for her! Though she was plunged into darkness, though she was a "death bringer" to humanity (along with Adam), God's purpose for her had not changed—to be a life-giver.

In the same way, throughout the Gospels, we see women from all different walks of life who are restored from sin and dire circumstances: a woman suffering from a discharge of blood for twelve years who was considered unclean (Mark 5:25–34), a widow who had lost her son (Luke 7:11–17), a woman with a disability (Luke 13:10–17), a woman caught in adultery (John 8:1–11), a Samaritan woman who had had five husbands and was living with an additional man (John 4:1–26), and a woman from

whom seven demons had been cast out (Luke 8:2). Jesus graciously and lovingly acknowledged, healed, and redeemed these women and many more. The One who was promised to Eve so long ago arrived in human history and brought salvation to many women who had been oppressed by sin and devastated by its effects. Jesus brought restoration to these women, and many of them became His followers who accompanied Him as He went from town to town preaching the good news of the kingdom (Luke 8:1–3).

As a response to their redemption, many of the women portrayed in the Gospels lay down their lives for the sake of the kingdom and commit to serving the Lord in various ways. Similar to Eve, where they once experienced such darkness and death, they now become redeemed life-givers everywhere they go. Some of the wealthy women who followed Jesus supported Him and His disciples (Luke 8:3), others evangelized (John 4:39), some worshipped Jesus through extravagant means (John 12:1–8), and we discover that the choice to sit at Jesus' feet to learn from Him is a preeminent priority for a woman over and above busying herself with other tasks—even tasks done in His name (Luke 10:38–42).

While these examples are not exhaustive, they highlight the restoration of women to a place of service in the kingdom that echoes back to the calling of both men and women in Genesis 1 to use their lives to bring honor and glory to God in the world. Thus, we see the women of the New Testament Gospels following Christ as disciples, alongside men, using the various situations of their lives to serve Him and bring the gospel to others. They show us the ideal biblical woman—one created in God's image

reflected in the fact that she is given equal status with male disciples, one who exhibits a fallenness that expresses itself in various detrimental ways in her life but who has been graciously loved and redeemed by Jesus, and who then seeks to love Him with her whole heart, soul, mind, and strength by living wholly dedicated to God as a life-giver. Because He saved every part of her, she loves Him back with all she's got.

Discussion Questions

1. What are some of the various ways you've tried to be a "biblical woman"? After reading this chapter, what do you think it means to be a biblical woman?

2. What are some ways women can partner with men and fulfill their design as helpers?

3. Contemplate the effects of the fall on womanhood. In what ways has the fall impacted you specifically—in your heart? Your soul? Your mind? Your physical strength?

4. Have you personally committed yourself to Jesus? Have you by faith accepted Him as your Prophet, Priest, and King? Like the women of the New Testament who were restored, in what ways has Jesus personally restored you?

5. How can you live out your purpose to be a life-giver in your current spheres of influence?

2

THE IMPORTANCE
OF SCRIPTURE

Emily Dean

> Simon Peter answered, "Lord, to whom will
> we go? You have the words of eternal life."
> —JOHN 6:68

Introduction

In the fall of my sophomore year of college, a friend asked me to go to a Bible study with her. Little did I know that one Bible study invitation would awaken a lifelong passion in me for the study of God's Word. As I began to study Scripture, changes began to occur in my life. I was being transformed by the Word of God. I found so many treasures in the study of the Bible that I couldn't get enough. I had found the words that breathed life into

my soul, the kind of life I had been longing to have. I found that not only did God's Word show me the way to salvation, but it also showed me the way to live. As I read Scripture, I discovered that God's Word has a lot to say about life and much to say about me as a woman.

Why is the study of Scripture important for women, and what does the Bible say about what it means to be a woman? These questions have taken me on a lifelong journey of discovery to find out what God's Word really says. I found that God indeed has a good, gracious, and unique plan for me as a woman. I discovered that God wants the best for me, and His best is a life filled with peace, joy, and hope. I found that being a woman is something to be celebrated as God's creation rather than defended or downplayed as culture might have us believe. When God looked upon His creation after completion, God said that it was good (Gen. 1:31), including His creation of women! Yet how would we know that God's creation of women is good without reading Scripture to find out?

Most women would admit that they need help with things that concern them like anxiety, finances, physical health, parenting, or challenging relationships. Yet how many know that God's Word has something to say about all of those life stressors? The study of Scripture is important because God's Word reveals to us the path to a saving relationship with God through Jesus Christ. Not only does Scripture show us the way to Jesus for all eternity, but it also reveals to us the way to follow Jesus in the here and now—right in the midst of all those various struggles in which

we long to experience victory. Scripture shows us the route to the best life we could live on this earth as it reveals to us how to be reconciled to God through the work of the Son. And through this reconciliation it leads us to hope, joy, and eternal peace. This chapter will help us see why Scripture should be the foundation of our lives. To understand how Scripture can make a difference in our lives as women, we can help one another AIM rightly by:

- Acknowledging the **Authority** of God
- Affirming the **Importance** of His Word
- **Making** application in light of what it says

Authority of God

All of us answer to someone. We answer to bosses, to family members, to the government, to spiritual leaders in our church, and so on. Even in the most extreme individualistic cultures (the United States being a prime example), we are still accountable to other people for our choices. Yet often we want to run from authority. We want to think that we are in charge and that no one besides ourselves will be affected by our decisions. Why is that? As discussed in the previous chapter, since the fall of man in Genesis 3, we have been trying to live life our way. The problem is that living life our own way never ends well.

Scripture reveals to us that ultimately all of us answer to a Holy God who is Creator, Sustainer, Redeemer, and righteous Judge. We see that God is in charge, and we are not (Isa. 40:13–14).

How does Scripture reveal to us that God is Creator, Sustainer, Redeemer, and a righteous Judge?

As Creator

In Scripture we find that God creates because He alone has the authority to give life (Gen. 1:27). He has dominion over the whole universe. Though we are given authority to oversee the earth, that authority is delegated. It comes from God, not ourselves (Gen. 1:28). Whether having the opportunity to study Scripture or not, humans intuitively know that we are accountable to a Creator because God reveals Himself to us through His creation (Rom. 1:20). Whether it's taking care of animals or farming food or raking leaves, all humans—religious or not—can instinctively sense that we are stewards of God's world and that we'll give some sort of account for how we handled what we were given. Yet beyond this general understanding, to better and more specifically understand who this Creator is to whom we are accountable, we need His Word to guide us.

In addition to creating the world and all its inhabitants, God is the Creator and Author of His Word (2 Tim. 3:16–17). The apostle Peter confirmed God's role in creating Scripture when he said, "Above all, you know this: No prophecy of Scripture comes from the prophet's own interpretation, because no prophecy ever came by the will of man; instead, men spoke from God as they were carried along by the Holy Spirit" (2 Pet. 1:20–21). We can trust God's Word knowing that it indeed comes from Him,

and His Word is truth because He is truth (John 14:6; 17:17). Through God's Word, He shows us the way to live rightly according to His truth.

As Sustainer

God reveals to us in Scripture that He not only made His creation, but He also continuously *takes care* of His creation. God's Word is the perfect antidote to a society fraught with anxiety. He reminds us that if He carefully provides for the plants and animals, then He will take care of us too. In fact, God goes so far as to command us not to worry (Matt. 6:25–34). He sustains "all things by his powerful word" (Heb. 1:3).

As Sustainer, we can trust that God will protect us (John 17:11, 15). We can depend on Him for all things that concern us because He cares about us (1 Pet. 5:7). We can trust that God will provide for us (Phil. 4:19). God says that He will "never leave you or abandon you" (Heb. 13:5). God knows we need protection and provision, but He will always sustain us.

As Redeemer

From Genesis to Revelation, God reveals His story of redemption. Beginning with Adam and Eve in Genesis 3, God shows His desire for a restored relationship with mankind. Throughout the Old Testament, God continued to bring redemption to His chosen people through a covenant relationship with them (Deut. 7:6–9). The Israelites were to be a shining light to the other

nations so that all people would know that their God is the whole world's God, too.

In the New Testament, God reveals His redemption story through the person of Jesus Christ. Jesus made a way for us to come to God in repentance and faith through becoming a living sacrifice (Heb. 10:10–12). This sacrifice made such an impact on human history that even secular dictionaries define *Redeemer* as "Jesus Christ!"[3] God reveals to us through His Word that He is continually in the business of redeeming, first through the Old Testament covenant system and now through the atoning work of Jesus Christ.

As Righteous Judge

While God desires to reconcile mankind to Himself, He is also a righteous Judge. He is gracious and compassionate, but He is also just and truthful (Ps. 103:6, 8). God is holy and therefore cannot be in the presence of anything unholy (Lev. 19:2). Since the fall of man, every human has fallen short of God's standards and needs the saving grace of Jesus Christ to stand before a holy God (Rom. 3:23–24). God must judge the earth because sin has so ravaged His creation, yet God is also fair in His judgment (Ps. 9:8). While sin brings the consequence of death, ultimately God has provided a way of eternal salvation through Jesus Christ (Rom. 3:25–26), satisfying God's own requirement for justice.

[3] "Redeemer," Dictionary.com, https://www.dictionary.com/browse/redeemer?s=ts.

We all instinctively know that judgment is needed in life. Our fallen nature often seeks revenge for injustices, but judgment ultimately belongs to the Lord (Rom. 12:19). That's not to say, however, that believers should turn a blind eye to injustice. Followers of Jesus are called to speak up for injustice (Prov. 31:8–9). It is not our responsibility to take revenge on the unjust, but we are expected to speak up for those who cannot speak for themselves. We are to serve as advocates for the oppressed and let God serve as righteous Judge for all people.

Importance of His Word

To know why God's Word is important, we must first understand what the Bible is. According to Lifeway Research, only 36 percent of Americans believe God's Word is true, and only 23 percent said they had read all or almost all of the Bible.[4] Where do you fit in these statistics?

As a teacher, I love tests! So please humor me and take the quiz below. Choose the answer that you believe to be accurate about the Bible.

1. The Bible is:
 a. a book of distinct and separate chapters
 having nothing to do with one another

[4] Lizette Beard, "Podcast Episode 19: Bible Engagement and Its Impact on Spiritual Growth," Lifeway Research, June 15, 2017, https://lifeway research.com/2017/06/15/episode-19-bible-engagement-and-its-impact -on-spiritual-growth/2.

 b. a totally separate Old Testament and New Testament

 c. a single unit

2. The Bible is:

 a. a collection of interesting teachings by different people

 b. a good book but not necessarily directly from God

 c. God's way of revealing Himself to man

3. The Bible is:

 a. good literature

 b. inspired by man

 c. inspired by God

4. The Bible is:

 a. a book filled with errors

 b. part accurate, part inaccurate

 c. a book without error or fault in its teaching (inerrant)

If you answered *c* for all of the questions, you are correct! Knowing these four aspects of the Bible is crucial to accurate Bible study because what women believe about God and His Word will determine how they study Scripture. The Bible is **a single unit**. It is one book written by many authors. We must know this so that when we come to a passage of Scripture that is difficult to understand, we can look at how it compares to other Scriptures. The Bible is also **God's revelation** (Heb. 1:1–3). This means that God wants to speak to us. He wants to reveal who He is to mankind,

and He wrote His Word through human authors so that we could know Him. The problem is not that God fails to speak to us. Usually the problem is that we do not want to listen.

The Bible is **inspired by God** (2 Tim. 3:16–17; 2 Pet. 1:21). Through the Holy Spirit, God led the authors of Scripture to write what He wants to say to us. If we do not believe the Bible is inspired, then it will be just another good book. For life transformation to occur, we must believe that "the word of God is living and effective and sharper than any double-edged sword" (Heb. 4:12). Also, the Bible is **inerrant** (Matt. 5:17–18). *Inerrant* means that the Bible is entirely accurate, without error. For the Word to be God's revelation and inspired by God, then His Word must be true because Jesus says, "I am the way, *the truth*, and the life" (John 14:6, emphasis added). If God's character is that He is truth, then His Word must be entirely true as well.[5]

Authority Based on the Author

Remember when you were a child playing at a friend's house, and your mom called to say it was time to come home? What happened? You went home. Those words had authority because of who spoke them. In much the same way, God's words have authority because He has authority. Put another way, His Word has authority because He is the author. Our beliefs about the Bible

[5] Howard G. Hendricks and William D. Hendricks, *Living by the Book: The Art and Science of Reading the Bible, Revised and Updated* (Chicago: Moody Publishers, 2007), 26–28.

do not negate its truth. In praying to the Father, Jesus said clearly, "Your word is truth" (John 17:17). The Bible is true regardless of whether we believe it because God is truth (John 1:1). As we accept God's authority in our lives, only then will we recognize the authority of Scripture to speak truth into our lives.

It Speaks in Some Way (Sufficiently) to All of Life

To understand how Scripture speaks sufficiently to all of life, 2 Timothy 3:16–17 explains that all Scripture is "profitable for teaching, for rebuking, for correcting, for training in righteousness, so that the man of God may be complete, equipped for every good work." For example, while Scripture may not speak specifically to social media use (since it was nonexistent prior to the twenty-first century), it does give guidelines on how to communicate with people in a Christ-honoring manner. The Bible may not tell parents when and how to allow privileges to their children, like using technology or driving a car as they get older, but it does provide overarching wisdom on parenting, which will inevitably be applied to these kinds of specific situations. With any challenge we may face, the Scriptures offer guidance on how to approach it. All Scripture is profitable and useful for navigating life's challenges, and it speaks in some way to everything we encounter.

It Speaks the Way of Salvation

In Scripture we find that Jesus is the way to God (John 14:6). John also tells us: "For God loved the world in this way: He gave

his one and only Son, so that everyone who believes in him will not perish but have eternal life" (John 3:16). God revealed His plan for redemption through His Word. Even the Old Testament pointed to Jesus as the coming Messiah. Numerous Old Testament passages testify to the coming Messiah, but particularly poignant is Isaiah 7:14, where Isaiah outlines God's plan: "Therefore, the Lord himself will give you a sign: See, the virgin will conceive, have a son, and name him Immanuel." Matthew quoted this passage in the New Testament as he told the account of Jesus' birth, confirming that Isaiah's prophecy pointed to Jesus (Matt. 1:23).

God wants all people to know Him, and the way we come to know Him is through His Word (Rom. 10:14–15). We as women have the incredible opportunity to know the one, true holy God through reading His Word. In response, we're then able to love Him with all of our heart, soul, mind, and strength. Then we have the amazing privilege of sharing His Word with others, helping them, in turn, love Him with all they are as well. In our American culture, where access to a copy of the Bible is available at the click of a button, we often take for granted the precious words contained inside. Complacency toward Scripture is easy. The challenge is to actually pick it up and read it. Only then will we find the pearl of great price that is worth everything (Matt 13:45).

Making Application

Why is the study of Scripture important? Most women would say they want a life that works. In the busy society in which we

live, women are looking for help with life management, aren't we? We search online for tips on how to manage everything from our home to our time to our health. And yet the key to a life that works is found in God's Word.

Reliance on God's Word

When life gets challenging, where do we as women turn? Do we turn to people, food, technology, substances, or do we know that we can turn to God through His Word? God's Word should be the first place we look when life gets hard. Studying Scripture must become for us as important as our daily food (John 6:51). We all have to make time to eat every day. If not, our stomachs will remind us! Are you and the women you know truly hungry for the words of life? If hunger for the Word of God is not present, begin to pray. Pray for God to bring deep desire for His bread. Pray that He would increase your love for Him and His Word. Pray for God to give you and women in your sphere of influence a hunger for His Word. Reliance upon His Word is the key to transformation.

A Proper View of Self and Others

God's Word reveals to us how God sees us. While the world may communicate to women that they are neglected, forgotten, without hope, unloved, or rejected, God says that His children are chosen, adopted, redeemed, loved, and accepted (Eph. 1:3–8).

God reveals through His Word that before we were even conceived, He knew us (Ps. 139:13–14).

God's Word also helps us see not only that we are important to God, but that all people are important as His image bearers (Gen. 1:27). This means that men and women were intentionally created to be like God in distinctive ways that the rest of His creation is not. Viewing people from the lens of God's Word then dramatically changes our understanding of the value of people. People are not just objects to be used and discarded. They aren't just valuable for what they can produce. Women bear the image of God. We understand that every man, woman, and child on this planet are important because they are God's creation. Because of these realities, they deserve honor and respect. They also deserve the love that God commands we have for our neighbor.

Imperative to Obey Commands

For life transformation to occur, we must be willing to make a decision to obey God's commands. Until we are willing to take God seriously at His Word, our lives will stay the same. There can be no transformation without obedience. No one can make the decision for us to be disciplined in Bible study. No one can actually study the Bible for us either! We have to decide that we are going to study the Bible and then act on what God shows us. For many of us, the process stops right there. We can easily think about what a good idea it would be to study the Bible, or acknowledge that the Bible offers "helpful principles" for life, yet

never make a conscious decision to do anything about it in actual practice. That must not be so for us.

Once we make the decision to be disciplined, the best way to act on it is to make a schedule or a plan. When is the best time to study the Bible? Everyone is different and has a different schedule, so each of us should find the time that works best. If you do not think you have any time available, create a time sheet with each hour of the day represented, and fill in your daily activities. When you look at how you spend your time, you may find that you have more time than you think. Also know that sometimes those plans have to be adjusted. You may want to try out a certain time of day, and if it does not work, try a different one until you find something that works. We all have to keep trying; we can't give up simply because it's hard or inconvenient.

Finally, we can inspire one another as women to follow through. If we don't follow through, Bible study will just be something we wish we did.[6] Follow-through can be really tough when it comes to Bible study. However, we all make time for what we want to do. If we want to know God through studying His Word, we will find the time to do it. But once we have studied, we must put what we read into practice. Remember, though, that God gives us His Spirit to help us! As believers, as we journey through studying Scripture and applying it to our lives, the Holy Spirit will be with us every step of the way. Pray for the Holy Spirit to help you and women in your sphere of influence to AIM rightly:

[6] Hendricks and Hendricks, *Living by the Book, Revised and Updated,* 362–64.

acknowledge the authority of God, affirm the importance of His Word, and make application to your lives today!

Discussion Questions

1. What hindrances to studying Scripture do you and other women often face?

2. How does understanding the authority of God change the way you view Scripture?

3. In what ways is Scripture sufficient to give guidance for every aspect of your life?

4. How have you seen the study of Scripture make a difference in your life?

5. How can you help other women see the value in relying on God's Word?

A WHOLE-PERSON MINISTRY

Kristin L. Kellen

"To love him with all your heart, with all your
understanding, and with all your strength, and to
love your neighbor as yourself, is far more important
than all the burnt offerings and sacrifices."

—MARK 12:33

Introduction

This book began with a necessary reminder of the truth of
the gospel: in the beginning, we were created as good, but sin
ushered in death at the fall. God, in His great mercy, sent His Son
Jesus to pay the penalty we deserve for that sin, bringing us back
into a right relationship with Him. We deserved none of that; the
wages of our sin was death, but the gift of God is righteousness
through Jesus (Rom. 6:23). Chapter 2 of this book then discussed

the importance of understanding God's Word, specifically that it helps us to AIM rightly toward our Creator. When we understand the authority and importance of the Bible, we can make proper application in our own lives—two major applications being the way we view ourselves and others and the way we view biblical commands (as imperative and requiring obedience).

If we were asked, most of us could recite the great commandment given by Jesus in Mark 12: to love God and to love others. And most likely we could give affirmation that we seek to do those things. But do we really understand what it means to love God and love neighbor in a full and holistic way? Volumes have been written on the love of God and love of neighbor, so why revisit that topic here? Because part of our love for our neighbor is spurring them on toward a whole-person love of God. Put another way, as part of my love for my neighbor, I am called to minister to every part of her so that she can love God more fully. We'll get to some specifics later on, but for a moment, let's revisit Jesus' conversation in Mark and glean some foundational teaching for moving forward.

The Great Commandment: Understanding Mark 12:28–34

> One of the scribes approached. When he heard them debating and saw that Jesus answered them well, he asked him, "Which command is the most important of all?"

Jesus answered, "The most important is Listen, O Israel! The Lord our God, the Lord is one. Love the Lord your God with all your heart, with all your soul, with all your mind, and with all your strength. The second is, Love your neighbor as yourself. There is no other command greater than these."

Then the scribe said to him, "You are right, teacher. You have correctly said that he is one, and there is no one else except him. And to love him with all your heart, with all your understanding, and with all your strength, and to love your neighbor as yourself, is far more important than all the burnt offerings and sacrifices."

When Jesus saw that he answered wisely, he said to him, "You are not far from the kingdom of God." And no one dared to question him any longer.

We often find Jesus in conversations with Jewish religious leaders, and this exchange is one of those conversations. Just prior to this passage, Jesus was questioned by the Sadducees, an upper-class religious sect known for their focus on the Mosaic law. More specifically, they tried to trick Jesus by asking Him about marriage after the resurrection. Verse 28 indicates, however, Jesus "answered them well"; as Matthew reports of the same encounter, Jesus "silenced" their questioning (Matt. 22:34).

Immediately following, the Pharisees yet again seek to trick Jesus. This was not a new tactic; the Pharisees often sought to trick Jesus into heresy to demonstrate that He was not who He claimed to be. Matthew 22:35 indicates this motivation: "One of them [a Pharisee], an expert in the law, asked a question to test him." His aim is malicious here; he wants Jesus to choose one of the commandments at the expense of the others. So this scribe asks: "Teacher, which command in the law is the greatest?" (v. 36).

Jesus, knowing both the scribe's motivation and the true answer, replies with two commands. First, He says, "Love the Lord your God with all your heart, with all your soul, with all your mind, and with all your strength" (Mark 12:30). At this moment Jesus is pointing the scribe toward a core Old Testament teaching that he would have been familiar with. The book of Deuteronomy often commands God's people to love the Lord with all of their being, most notably in Deuteronomy 6:5, which required loving God with "all your heart, with all your soul, and with all your strength."

Jesus immediately follows with a second command: "Love your neighbor as yourself" (Mark 12:31). Just as followers of God were to love their Creator fully—with every part of their being—so, too, were they to love their Creator's image bearers. The two commands go hand in hand, and as was recorded in Matthew 22:40, Jesus said, "All the Law and the Prophets depend on these two commands." Jesus has summarized the entire Hebrew Bible in these two simple phrases.

By God's grace, the scribe understood Jesus' teaching. He responded: "You are right, teacher. You have correctly said that he is one, and there is no one else except him. And to love him with all your heart, with all your understanding, and with all your strength, and to love your neighbor as yourself, is far more important than all the burnt offerings and sacrifices" (Mark 12:32–33). This scribe recognized, as we must, two important truths. First, there is no other god but our God. Just as He is the foundation and source for the law in the Old Testament (Deut. 6:4), so, too, is He for us today. Second, obeying these two commands is the desired offering of our God. This is not a new concept: Samuel said in 1 Samuel 15:22, "To obey is better than sacrifice," and the writer of Proverbs said, "Doing what is righteous and just is more acceptable to the LORD than sacrifice" (Prov. 21:3). Though literal, physical sacrifice was the norm at that time, Jesus Himself would ultimately satisfy that requirement. And at the root, sacrifices were primarily paying for lack of obedience. Obedience is certainly better than offering a sacrifice, for when we obey God, there's no need for a sacrifice to cover disobedience. In short, God was far more pleased when His people obeyed instead of having to go through painful sacrifices to deal with the instances where they didn't obey. Thankfully for us, Jesus offers both—He lays down His own life as a sacrifice for our sin and also offers us an obedient record in all the places we disobeyed!

Jesus' response to the scribe should give us great encouragement. Just as the Holy Spirit enabled the scribe to see the truth in that moment, so, too, should we be encouraged when we come to

the realization of the same truth. As it was for him, so it is for us: our true act of worship is to love God and love others fully, with every part of our being. When we understand this command and put it into practice, we, too, will be "not far from the kingdom of God" (Mark 12:34). In other words, we will be living the way God intended for us to live.

Ministering to the Whole Woman

So how does this translate into a whole-woman ministry? Why do we also seek to minister to the heart, mind, soul, and strength of other women? Think about it for a moment: If every woman we encounter, every woman who ever lived, was created to worship God with all of her heart, soul, mind, and strength, what happens if she is struggling in one or more of those areas? What if she's struggling with intrusive thoughts about failure and inadequacy? Or what if her emotions are out of kilter? Those struggles will directly translate into struggles of worshipping the Lord in those ways. Put another way, a whole-person ministry focuses on holistic well-being *in order to* propel the person toward holistic love and worship. We love our neighbor more fully because it helps her worship God better. It also brings her to the place of loving her neighbor more fully, creating a domino effect as others are impacted by this love.

Because of these realities, our aim in this book is to demonstrate how we can minister to one another as women in all spheres of life, with the ultimate aim of helping women love God and

worship Him more fully. Often we don't recognize when disorder creeps in, not until it is full-blown. And yet, if we sit and think about it deeply for a moment, all of us could put our finger on an area where we struggle. God has called us to live in community with one another, loving one another as neighbor, to help us point out those areas of struggle and help us rectify them. We are blind, many times, to our own sin; one aspect of loving neighbor is compassionately identifying those areas of sin and weakness and spurring one another on toward Christlikeness and Christian maturity (Eph. 4:15).

In light of this, what might a whole-person ministry look like? How would we minister to other women's hearts, souls, minds, and strength? Let's take a brief look at these components to give us a framework for moving forward.

Heart

Proverbs 20:5 tells us: "Counsel in a person's heart is deep water; but a person of understanding draws it out." When we consider our sisters and brothers, often we first notice external things like what they say and do. But the writer of Proverbs reminds us that it is possible to look deeper, to be women who can understand and draw out the internal things hidden below the surface that drive our behavior. To do this, though, we must get at a woman's heart: her emotions, her motivations, and her desires.

So often we as women are driven by these things. Many of us are feelers; we feel something and act on it. And undergirding those

feelings are beliefs (Rom. 10:10), values (Matt. 6:21), intentions (Heb. 4:12), and other motivators. As a counselor, I've realized that if I simply address a woman's behaviors or even her thoughts, my ministry to her through counseling does little. However, when we love one another fully, addressing the heart and all that is contained within it, our ministry is much more effective. Given that "God's love has been poured out in our hearts through the Holy Spirit" (Rom. 5:5), He cares tremendously about our hearts, and so should we.

Soul

While we often use different words for this concept, in saying "soul," we are referring to the spiritual life of a woman. More specifically, her relationship with the Lord and spiritual maturity, something that is of utmost importance to God (as it should be for us). As we consider ministering to women in these realms, oftentimes this is what naturally comes to mind when we think of discipleship: how we can teach others about the Lord and help them walk with Him.

Sometimes we approach spiritual ministry to others on a surface level. We think, *Well, she says she's a believer and she prays, so what more is there?* And yet, as Paul writes in Ephesians 3:17–19: "I pray that you, being rooted and firmly established in love, may be able to comprehend with all the saints what is the length and width, height and depth of God's love, and to know Christ's love that surpasses knowledge, so that you may be filled with all the

fullness of God." A woman's soul should long for the depths of God's love; as we minister to her soul, we can point her in this direction. Ministering to the women around us can certainly include all sorts of things—practical solutions for problems in their marriage, their parenting, their work, and so on—but if the aid we give does not include *spiritual* help, we aren't ministering well.

Mind

We cannot ignore the reality that we are cognitive creatures; we are aware of and think about ourselves often. Furthermore, our thoughts drive so much of what we say and do, particularly when those thoughts become disordered. And yet, when we think about ministering to women in this area, often we think this stops at Bible knowledge. If a woman simply learns more, we think, she'll do better or be better.

But what is she to think of? What is it that is so vital to her that she cannot live without? As we minister to women, we want to address two key areas: her thought life and her theological study. (We'll fully explore these in future chapters.) Our thoughts are private things, and many of us guard ourselves from sharing our thoughts with others. But in order to minister to one another, we must be willing and vulnerable, encouraging one another to be transparent about what's going on in our minds. God cares deeply about our thoughts; several times He issues warnings against our mind being focused on the wrong things (Rom. 12:2; 2 Cor. 10:3-6;

Phil. 4:8). Just as God is concerned about the focus of our thoughts, so, too, should we be concerned about these things.

Strength

Finally, we can minister to others in all of their strength. What gives them energy? What makes them strong? Use these questions to guide you toward thinking about how to minister in these ways.

In the upcoming "strength" section, we'll look specifically at a woman's body (as that gives her physical strength) and her community (as we find strength in God's body, the church). As for a woman's physical body, sometimes the most natural way for us as women to minister to another is through meeting physical needs: cooking a meal for someone who is sick or bringing coffee by for a friend. But ministering to a woman's body can be more than that, as we'll explore soon. And in thinking about her community, we'll discuss how we can exist as the type of community God intended, strengthening and building up one another. Like the other three aspects above, here again we care about a woman's body because God cares; it is the literal temple of His Spirit (1 Cor. 6:18–20), redeemed at a great price.

Conclusion

As we can see, a whole-person ministry is expansive; it touches on every area of a woman's life in order to spur her on toward a whole-person worship of her Maker. If you're like me, this might

feel a bit daunting. How are we to do ministry in such a way that it encompasses so much? There are two simple answers: a little bit at a time, and not in our own power. Let me start with the second. God enables us by His Spirit not only to understand His Word but also to obey it (Ezek. 36:27; Rom. 8:12–13). God enables us to carry out this task of loving one another fully, just as He enables us to love Him in the first place (Eph. 1). Therefore, if we are to love one another more fully, we must aim to do it by His power through His Spirit, not by ourselves. And we begin one step at a time. A whole-person ministry does not come about overnight; it is built brick by brick.

As you read through what it means to minister on each of these levels, take some time after each chapter to reflect on what it might look like to put that one piece of this puzzle into practice that week. Consider the questions at the end of each chapter and how they might encourage you toward ministering to other women in that sphere of their life. Consider, too, where you might need some encouragement. As I said above, all of us can probably identify areas in which we have needs as well. But also ask the Lord to show you areas of need in yourself and in others, along with His help in meeting those needs. As you embark on this journey, remember the good news that God gives us in Philippians 1:6, that "he who started a good work in you will carry it on to completion until the day of Christ Jesus." He will help you obey His Word, for His praise and His glory.

Discussion Questions

1. As you read through the brief summary above for each of the four areas of ministry, what are your initial thoughts about where your needs may be?

2. Before going through the four major sections that follow (heart, soul, mind, and strength), in which area(s) do you think you are experiencing the most health? In which area(s) do you anticipate needing some growth?

3. How might your life be different today if you had received whole-person ministry growing up?

4. Think of one or two women you'd be willing to invest in over the coming weeks. If you're willing, share with someone else for accountability.

INTRODUCTION TO
HEART SECTION

Guard your heart above all else,
for it is the source of life.

—PROVERBS 4:23

A woman's life flows out of her heart; her emotions, her moti-
vations, and her desires drive all that she thinks and does. The
heart is perhaps the most important indicator of who a woman is.
And yet, do we think about the hearts of others when we seek to
minister to them? Do we dig deep into a woman's deepest moti-
vations and desires, and then seek to align those fully with God
and His Word? Do we explore emotions in all of their complexity
as more than just feelings but as indicators of beliefs and values?
In this section we'll explore emotions, motivations, and desires,
specifically looking at common areas of struggle and ways we can
minister to others in these arenas.

4

EMOTIONS

Julia B. Higgins

Patience is better than power, and controlling
one's emotions, than capturing a city.

—PROVERBS 16:32

Introduction

"She's so emotional." Many women have uttered this phrase about a friend, a coworker, or even a family member. Other women sometimes declare to loved ones, "I'm sorry. I'm just so emotional." But what do these comments reveal about us when we talk about other women or ourselves this way? At some level, statements like these indicate that we perceive emotionality to be a negative aspect of female personhood.

Maybe we interpret female emotions as bad because literature and art have stereotyped emotional women, or maybe we have

been influenced by hyper-feminist philosophy that pushes us to reject the parts of us that would not survive in male-dominated environments. Even in the church we have been told not to follow our feelings, reinforcing the idea that feelings are inherently bad.

In contrast to the idea that being emotional is bad, we see God in the Scriptures having emotions and expressing them in a proper way for the good of His kingdom and the good of people. This idea—that God possesses and expresses emotions—tells us that it is okay for us to do the same. In fact, expressing emotions is yet another way for us to image God and bring Him glory. Yet we often take good emotions and express them in ungodly, dispro-portional ways. We must not reject emotions altogether but seek to bring them under the lordship of Christ so we can image God, love Him with all our heart, and love others well.

Consider three primary emotions and how they can be used in an ungodly or a godly way: love, anger, and fear. Love may be shown in self-sacrifice and service toward God and others, or it can be exhibited selfishly and result in self-love, a priority of self over all others. Anger can be exhibited in righteous ways (indig-nation against sin and its effects on others) or unrighteous ways (yelling, screaming, mistreating). Fear can reflect reverence for and trust in the Lord, as well as pushing us to pursue the health and safety of others. Or it can lead to anxiety, worry, and distrust of God and other people. Because emotions can be expressed in godly or ungodly ways, we must understand that the main func-tion of emotions is not self-expression but to reflect God's image and, thus, bring glory to Him. This chapter will help us think

through what the Bible teaches concerning our emotions, the role of the emotions in a woman's life, common areas of struggle for women, and applications for ministry to women.

What Does the Bible Say about Our Emotions?

To best understand ourselves, we must first understand the God who made us. The Bible teaches us about the character and personality of our Lord, and part of what we find in Scripture is that God displays various emotions. The context for understanding God as an emotional being is found in knowing that God is *impeccable* in His character. The "impeccability" of God means each person of the Trinity has never sinned and will never sin. God the Father, God the Son, and God the Holy Spirit are incapable of sinning (James 1:17; Matt. 5:48; 1 John 3:5). Thus, when God demonstrates emotion, He does so with no hint of evil or influence of depravity. Though *we* are fallen and our emotions are subject to the effects of the fall of man, we must remember that the crucial distinction here is the fall of *man*, not God. God is not fallen, and His emotions remain uninvaded by sin. He simply cannot express His emotions any other way than correctly. The fact that God is impeccable is the lens through which we consider God as an emotional being.

Some (but not all!) of the varied emotions God displays in the Bible include love, compassion, hatred, jealousy, and anger. Ephesians 2:4–5 teaches us that God feels such a deep love for us that He is compelled to demonstrate His feelings toward those

caught in sin: "But God, who is rich in mercy, because of his great love that he had for us, made us alive with Christ even though we were dead in trespasses. You are saved by grace!" We also learn that our God is compassionate. *Compassion* is defined as "a feeling of deep sympathy and sorrow for another who is stricken by misfortune, accompanied by a strong desire to alleviate the suffering."[7] Psalm 78:38 speaks of God the Father who embodies this definition of compassion toward the people of Israel: "Yet he was compassionate; he atoned for their iniquity and did not destroy them. He often turned his anger aside and did not unleash all his wrath." In fact, the Father is actually given the title of the "Father of compassion" in the New Testament (2 Cor. 1:3 NIV). As for Jesus, Mark 6:34 reveals that Christ felt compassion when He looked upon the crowds as sheep without a shepherd. And John 14:26, in many translations, reveals the Holy Spirit to be a Comforter to God's people, a comfort that surely stems from His divine compassion on them.

We probably do not struggle with the thought of God's feeling emotions such as love and compassion because we view them as positive emotions. But what about emotions we deem to be negative, such as hatred, jealousy, and anger? Each of these emotions is not necessarily negative, for our perfect God displays these hard emotions in the right ways and at the proper times. The Bible offers many examples of God displaying each of these feelings. *Hatred*, for instance, is defined as "extreme dislike or

[7] "Compassion," Dictionary.com, accessed April 28, 2021, https://www.dictionary.com/browse/compassion.

disgust."[8] Psalm 11:5 reveals that God feels this emotion about those who are wicked: "The LORD examines the righteous, but he hates the wicked and those who love violence." Such a verse might make us feel uncomfortable because we may question the God of love also being a God who hates. Yet God is justified in feeling extreme dislike or disgust toward those who are wicked because they have rejected God's law, His righteous standards, and God Himself. God is worthy of every person's love, respect, and obedience, and when people do not act in a way that brings Him glory and honor, it is completely consistent with His character to strongly dislike and feel disgust toward sin and those who sin against Him. Therefore, through this example, what we perceive to be a negative emotion should be reframed in our thinking as a hard emotion that can be used positively to ultimately bring God glory. We are the ones who might take the hard emotions of hatred, anger, or jealousy and use them negatively or sinfully.

The fact that God Himself expresses a wide range of emotions leads us to understand that as image bearers (those made in God's image) we, too, should display a variety of emotions in ways that are consistent with the good nature of God. Otherwise, we wouldn't be reflecting Him well to the world. As a reminder of this, let's recall Genesis 5:1–2, where we are told the purpose of our very being—to reflect the likeness of God: "On the day that God created man, he made him in the likeness of God; he created them male and female." Therefore, if God is an emotional being

[8] "Hatred," *Merriam-Webster*, accessed April 28, 2021, https://www.merriam-webster.com/dictionary/hatred.

and expresses all emotions in the proper ways and times, our created nature demands that we do the same.

Yet again, because of the fall of man, our nature has been corrupted by sin. We have inherited a sin nature from Adam which influences our thoughts, emotions, and actions. Before sin, man was able to reflect all of God's emotions in an appropriate manner. But the influence of sin has marred our thoughts and emotions so that they tend to turn inward, preventing us from imaging and glorifying God as we should.

As we briefly discussed earlier, because of the fall, sin strongly binds us in a horrible predicament—we cannot please God and reflect Him rightly with our thoughts, emotions, and actions. The book of Romans teaches that all have sinned and fall short; no human is immune from the presence and power of sin. And like its impact on everything and everyone in this world, sin's effect on emotion is pervasive. Consequently, "a biblical view of emotion, while maintaining that the capacity for emotion is good, must account for sin."[9] We know that sin has permeated our hearts. But what does that effect really look like? As one counseling scholar puts it, sin's effect means this:

> Our emotions are no longer naturally oriented in such a way that they contribute to honoring, loving, and obeying God. Instead our emotions have become self-serving, our affections

[9] Sam R. Williams, "Toward a Theology of Emotion," Biblical Counseling Coalition, accessed July 29, 2019, www.biblicalcounselingcoalition.org/2011/07/27/toward-a-theology-of-emotion.

idolatrous, and our passion is for our own glory rather than His. We tend to seek happiness in what cannot last, delight in evil, fear that which God forbids, become angry when we should be patient, grieve hopelessly, and hate that which is good. Pervasive, holistic depravity means that not only do we choose and think the wrong things but also that our emotions, but for grace, are wrongly oriented.[10]

Sounds pretty bleak, right? Yet God doesn't leave our hearts or emotions in this state. God, out of His love, grace, and mercy, sent His Son (fully divine and fully human) to be our perfect representative. Jesus completely pleased the Father in every way, not only in His actions but also *in every emotion* He experienced on earth. For example, Jesus expressed anger and jealousy but did so righteously. In Matthew 21, we read about Jesus cleansing the temple and overturning the tables of the money changers. In His righteous indignation for the purity of God's temple, Jesus did not sin but expressed appropriate anger and jealousy for God's honor. Jesus didn't just *do* all the right things on our behalf; He *felt* all the right ways too, and His emotional record is given to us in the gospel, God seeing us as if we have always felt and expressed emotions perfectly.

You might be thinking, *Well sure, that was Jesus, but I'm not God.* Yet Christians have been freed from the power of sin and are filled with the Spirit so that they no longer have to give in to

[10] Williams, "Toward a Theology of Emotion."

any sin, including the ways we respond to and express our emotions. As believers in Jesus, when we bring our sinful inclinations under the lordship of Christ and the abiding power of the Holy Spirit, we are able to exercise godly self-control. The key, then, for the Christ follower is the redemption of our emotions for the purpose of loving God with all our heart and loving others as ourselves. This reorienting or repurposing of our emotions can only be accomplished when we cooperate with the transformative work of the Holy Spirit within us.

The Role of Emotions in a Woman's Life

Recently, I was driving and someone cut in front of me. Instantly, my flesh became irritated and frustrated. In that moment, after a brief instance of ill-treatment from another human being, I felt anger. My anger beckoned me to retaliate and get back at the person on the road by speeding up and somehow showing that person he couldn't treat me that way. On the heart level, I had already sinned against this person because my anger was ultimately self-focused. I was entirely concerned with my convenience, my importance, and my ways being violated (not concerned about *God's* ways being violated). And if I had chosen to respond to that anger by getting even with the person, I would have further sinned against my fellow man as well as the Lord. And that's just one moment of one day on the freeway.

We often don't think of the key role emotions play in our everyday moments and responses, but if we step back, we can see

that our emotional responses to a variety of situations influence our behavior. Our emotions have the capability of influencing us to please the Lord by imaging Him in a godly way or an ungodly, self-centered way. Therefore, we must become aware of certain emotions we are most susceptible to so that we reign them in, or perhaps redirect them, by the power of the Spirit, to love God with our whole heart and to love our neighbor as ourselves.

Worldly wisdom would say that the function of emotions is self-expression. But emotions haven't been given to us so that we might show off our desires, wants, needs, or personality. Rather, emotions are a good gift from the Lord to help us to be in proper relationship with Him and with humankind. The good emotions of joy, peace, love, and compassion are a means of reflecting the nature of God as well as considering ways to honor and serve those around us. The hard emotions of anger, fear, remorse, shame, and sadness can be inappropriately expressed or appropriately expressed. The table below reveals how these hard emotions must be reoriented to loving God and neighbor by seeking to express them toward God.

By way of reminder, let's recall that Jesus, the God-man, displayed these various emotions. He is the perfect human who expresses emotions correctly 100 percent of the time. Thus, when we feel a sense of failure, we can look to Jesus and know that we don't have to be perfect. He has been perfect for us. His righteous life has been credited to us, so that in union with Him, God the Father views us as He does Jesus. The knowledge of Jesus' perfection, even in the midst of our emotional responses, spurs us on to love God with our emotions as we seek to image Him as we were created to do, and love others well, as He has called us to do.

Emotion	Directed Toward	Inappropriate Expression	Appropriate Expression	Godward Action	Jesus in Our Place
Anger	Fellow man or God	Impatience or unkindness toward fellow man, displeasure with God	Righteous indignation against sin	Repentance from inappropriate anger, action on behalf of others wronged, trust in the Lord to act on one's own behalf, seeking reconciliation whenever safe and possible	At the death of Lazarus, Jesus experienced anger at the effects of sin on mankind, specifically in the life of Lazarus. Jesus expressed righteous indignation at sin by overcoming it with resurrection power.
Fear	Fellow man or God	Fearing negative judgments made by family, friends, strangers	Fearing the Lord	Repentance from fear of man, trust in the Lord, and submission to Him and His will	In the garden of Gethsemane, Jesus prayed to His Father, asking if it was possible if the cup could be taken from Him, yet He expressed submission to God's will.
Remorse and Shame	Fellow man or God	Regret for being caught in sin; self-pity	Godly sorrow and grief over personal sin and how it offends man and/ or God; proper humility; confidence that past sins have been paid for and can no longer be used by the enemy to accuse you	Seeking the Lord's help to rightly view sin and how it offends man and/or God; repentance from personal sin; trust that Christ's payment on the cross has already covered this sin and that God is just and faithful to forgive	Jesus never experienced regret over personal sin; He frees us from the weight of sin and removes our guilt and shame before God by His atoning sacrifice.

Emotion	Directed Toward	Inappropriate Expression	Appropriate Expression	Godward Action	Jesus in Our Place
Sadness	Fellow man or God	Self-pity; distrust of God	Mourning, lament, and/or expressing sorrow that finds ultimate hope in the person of God	Trusting the character of God by choosing to believe His promises to us; lament and prayer to God in the midst of sadness	Jesus wept many times, saddened by the effects of sin and death, and looked upon people with compassion. He also prayed to the Father when experiencing grief and sadness in the garden of Gethsemane.
Hurt/pain	Experienced inwardly but may also be directed toward fellow man or God	Self-pity, distrust of God; intentionally inflicting hurt and pain on someone else	Voicing your hurt and pain before the Lord.	Trusting the character and justice of God after voicing hurt and pain to Him	Jesus was betrayed by the disciples and shamed by ungodly men before and during the crucifixion. He did not revile in return and treated every enemy with forbearance, as well as speaking the truth in love.

The key takeaway about the role of emotions in the life of a woman is that they push us to right relationship (either with God or neighbor) and right actions (toward God and/or neighbor). We must be mindful of the role of emotions; otherwise, we may fall into the trap of being a slave to our emotions or struggling with their towering dominance in our lives. We will explore that idea in the next section.

Common Areas of Struggle

Everyone's experience with emotions varies, with all kinds of factors influencing that experience. Age, health, gender, personality, personal history and background, and life circumstances all mingle together and shape how we handle our emotional responses to life. But because we are women, made in the image of God, affected by the curse of sin, and redeemed, we can identify some commonalities in our areas of struggle with emotions. These commonalities include a lack of awareness of the biblical role of emotions, a lack of understanding how being female impacts our emotions, and the need for a balanced life.

On top of imaging God, another role of emotions is to help us make sense of situations we encounter so we can assess how we should respond and behave. But we can't decide how to respond or behave without being aware of the various emotions we have in any given situation. This type of mindfulness about emotions is the first step toward emotional regulation.

So, first, we need awareness about our emotions in order to regulate them and respond well. On top of that, to better understand and regulate our emotions, we also need an awareness of how our gender specifically impacts us emotionally. If our bodies are functioning properly, women go through a monthly cycle that includes the increase and decrease of hormones in our body. These hormones include estrogen, testosterone, and progesterone. While this fluctuation of hormones is normal and good, sometimes they contribute to feelings of anxiety, sadness, and irritability. Add to this something like pregnancy or menopause, and our emotions can be further impacted by these hormonal fluctuations. Hormones are not the enemy. They are a good part of our biology intentionally given to us by God. However, they, too, are impacted by the fall, and because of that reality, we all should grapple with how hormones might heighten emotional struggles in the various phases of our lives. While emotions and hormones are not sinful in and of themselves, we are faced with a choice to respond in a godly or ungodly manner when we sense them rise and fall.

Women in general are busy, which leads a lot of us to put our health low on our list of priorities. We juggle taking care of our homes, loved ones, jobs, church life, and educational pursuits, often at the expense of well-balanced eating, a consistent sleep pattern, and a commitment to exercise. If we could bump up our focus on the triad of eating right, sleeping right, and exercising, our struggle with emotions such as anxiety, fear, and worry may decrease. Consider how eating right portions of protein,

fruit, and veggies can keep you from being "hangry" (hungry + anger). Research the impact of increased cortisol levels upon anxiety (fight or flight responses) due to a lack of consistent exercise. Determine your absolute bottom line of needed hours of sleep and plan accordingly. Some seasons of life may prevent this (like having a newborn), but try to stay consistent over the long haul. Each of these three items that women struggle with will go a long way in helping us with our emotional regulation and responses.

Application to Ministry

Hopefully, this chapter has brought an awareness to the importance of engaging our emotions in our pursuit of loving God with all our heart and loving others above ourselves. I also hope we've learned about the need to discern our emotions so we can better regulate them and ultimately cultivate godliness in the midst of emotional response. Some of us may have already known these truths, or we may be facing them for the first time. Either way, women are called to teach and disciple other women in the vein of Titus 2. One area of discipleship that is lacking for women specifically is that of mentoring younger women as it relates to their emotions: awareness, discernment, and training in the cultivation of godly responses to their emotions. In other words, we could likely all benefit from accountability in this area.

To train women regarding their emotions, the best place to start is with a Word-centered approach. This small chapter cannot do justice to the variety of emotions experienced throughout the

Scriptures (either by God or biblical characters). Further study on emotions in the Bible within a small group of women could help in the development of what could be called a biblical theology of emotions (providing a comprehensive, holistic biblical understanding of emotions in the context of creation, fall, redemption, and restoration). Two specific topics that might be explored in the Bible are the emotive illustrations of mothering used in Scripture to give us further insight into God's compassion (Isa. 49:15; 66:13; Matt. 23:37), as well as how emotions are expressed in the Psalms. How can these emotive illustrations help us specifically as we seek to image God with our gender? An understanding of the Psalms as appropriated language provides comfort and peace in the ability to voice difficult, hard emotions before the God who cares for us deeply.

Conclusion

We may have different callings and vocations in life, but our highest call is to love God with all our heart, soul, mind, and strength and to love others as ourselves. This chapter has highlighted how we can use our emotions to honor and glorify God and serve others, with a specific call for us to look to Jesus in the expression of our emotions—especially when we fail to honor God by loving others with them. And we also considered the call to disciple and mentor other women in the area of emotions. We can conclude that emotions, when experienced and expressed rightly, are not bad; rather, emotions are a way we can express

God's image in the world. May the Lord increase our knowledge, discernment, and behavior as we seek to better understand this facet of how He has made us as women.

Discussion Questions

1. Have you ever thought about God the Father and Jesus experiencing and expressing emotions perfectly? What does this mean specifically for you in your day-to-day life?

2. In what ways do emotions push us toward right relationship with God and others?

3. What areas of your life tend to get imbalanced? Discuss your emotional experiences with a friend and how balance in eating, exercising, and sleeping might aid your emotional regulation.

4. When you realize that you've experienced or expressed an emotion that is not honoring to the Lord, how might you respond? What are some practical steps you can take immediately following that experience?

5

DESIRES AND MOTIVATIONS

Kelly King

Take delight in the LORD, and he will
give you your heart's desires.

—PSALM 37:4

Introduction

I was recently watching reruns of one of my favorite television shows, *Downton Abbey*. One of the things I love about the show is the witty jabs and wisecracks from the Dowager Countess of Grantham played by Maggie Smith. In this particular episode, she and Isobel Crawley were having a conversation centered on the dowager's prize-winning roses at the annual garden show. Knowing the dowager won each year because of who she was and not on the merit of her flowers, Isobel quips, "You don't usually win. You always win."

This was clearly a statement aimed at the dowager's motives and desire to always be on top, disregarding anyone else who might be worthy of winning. Isobel asks her about Mr. Molseley, a common villager who also regularly entered the competition whose roses rivaled any of the dowager's. After being questioned on her motives, the dowager snaps back, "What about my gardener's pride? Is he to be sacrificed on the altar of Molseley's ambition?"

Oh, yes. Ambition, motives, and desires. All of them speak to the heart of every woman. We all love to consider the words of Psalm 37:4: "Take delight in the LORD, and he will give you your heart's desires." And yet, how do we discern between our personal desires and selfish ambition versus pure motives and unselfish ambition? How can we experience godly desires that aren't produced by the idol factory in our heart? How can we approach a holy God who isn't a genie in a bottle but an all-knowing, all-powerful Creator whose will and way are often contrary to our own desires for promotion, position, or possessions?

In this chapter we'll explore how to approach our desires and motivations based on what the Bible says about them, we'll consider how easily our pure motives become impure motives, the role of motives in our lives, how common struggles affect us, how to develop pure motives, and how pure motives can positively affect our relationships. Finally, we'll see how pure motives make us more like Christ, our perfect example, who emptied Himself and provided a perfect example of unselfish ambition.

What Does the Bible Say about Motives and Desires?

Luke 6:45 specifically points out that our mouths speak from the overflow of our hearts. So our motivations and desires play a large role in what we say and what we do. For instance, recall the account of Simon the sorcerer from Acts 8:9–24. What was in his heart? He was interested in his own fame among his people and his own name getting the spotlight in ministry, which led him to try to harness the power of God's Spirit for selfish purposes. In short, he was only interested in God's power to build up his own influence and fame. And Peter rightly calls him on the carpet! While the Bible does not assume that human motives and desires are always bad (for example, Philippians 1:18 suggests they can be either false or true), Simon's story shows us just how destructive it is when our motives and desires are misdirected by sin.

Instead of being directed by sin, our motivations should be fueled by a love for the Lord and a passion for His desires. Proverbs 4:23 says, "Guard your heart above all else, for it is the source of life." When the word *heart* is used in the Old Testament, it has a deeper meaning than emotions. It often refers to the inner life of a person, the source of words and actions. The heart is the source from which life flows, which results in the behaviors of a person—both internal and external. Jesus explained this concept in the Sermon on the Mount when He taught about things like murder and adultery being sins we all commit on a heart level. His point was that external behaviors aren't just random actions; they begin in the core of a person's heart.

Yet in Christ we are redeemed sinners. Our motives and desires that come from our flesh are now crucified with Christ, and proper motives and desires are grown from the sanctification of the Holy Spirit. For instance, when we compare our lives to other women around us, we often experience the fleshly feeling of jealousy, which is born out of an impure motive. But as we put ourselves under the guidance and work of the Holy Spirit in our hearts, we can not only find contentment in the place God has *us* but even cheer other sisters on in the place God has *them*.

The Role of Motives and Desires in a Woman's Life

Motives and desires have a distinct role in revealing whether our heart has been transformed by the work of the Holy Spirit. Luke 6:45 says, "A good person produces good out of the good stored up in his heart." Here in this verse Jesus is teaching about a person who has been redeemed ("a good person") and thus exhibits good fruit, which is a result of sanctified motives and desires.

Once a woman has been saved by Christ and chooses to follow Him as Lord, her motives and desires will increasingly be directed by a love of God and love for others. In other words, her heart, which drives her behavior, leads her closer to the Lord. Proper desires, then, lead to loving God and loving others. A right heart results in an attitude of humility and denying self by placing God on the throne of our heart and by considering others before ourselves.

Furthermore, the Scriptures speak at length about aligning our desires with the Lord's, because when we do, our desires—the

right desires—will be fulfilled. Consider Psalm 37:4: "Take delight in the LORD, and he will give you your heart's desires." While the second half of the verse is what we tend to focus on the most, do you notice that he tells us what our heart's desire should be in the first part? The Lord! God desires to give us Himself; *He* should be our greatest desire. And when we desire Him, He fulfills that desire. We see this same idea echoed in Psalm 145:19, Isaiah 26:8, Matthew 6:33, and others. While we should always present *all* of our desires to God and trust Him with them, we must remember that it is in the Lord, and in Him alone, that we find full satisfaction.

Ungodly motivations (those which are overwhelmingly centered upon self) and desires which are contrary to a godly lifestyle help us discern one of two things: either we have not been redeemed by Jesus and therefore don't have a new heart that is being renewed in its motives and desires, or we *are* redeemed but are walking in the flesh and not in the Spirit. Thus, one of the roles that our motives and desires play is to show us our need of repentance. Our motives and desires point us somewhere—they reveal whether certain areas of our lives have been submitted to the lordship of Jesus, which may or may not need correcting.

Common Areas of Struggle

Though we all want totally pure hearts that desire only what God desires, the truth is, many of us struggle with various motives or desires that point away from God instead of toward Him. For

many of us, common areas of struggle are competition, comparison, and conflict. Let's explore each of these briefly.

I was raised in a family that valued competitiveness. Growing up, my younger sister was one of the fastest runners in our state. Her bedroom dresser was lined with medals, trophies, and ribbons from competitions she won. On the other hand, I played the piano. My competitions involved memorizing Bach, Mozart, and Chopin.

While I did well in those competitions, I never won a trophy. Eventually, I became determined to win one; it was a personal goal to achieve in order to make me feel valuable. So, when a new girls cross-country team formed in high school, my motivation for running wasn't to enjoy it or honor God; it was to win that coveted award at all costs! I would quote 1 Corinthians 9:24 before each race: "Don't you know that the runners in a stadium all race, but only one receives the prize? Run in such a way to win the prize." Surely God would smile on me and give me the desire of my heart—a trophy to display in the family trophy case.

After months of training, I finally won a trophy—twelfth place in the junior varsity division. (I know, aren't you impressed?) Nevertheless, the trophy was in my hand, and I couldn't wait to share the news. As I walked through the front door of the house, I tripped in the entryway, and the trophy fell out of my hands and broke into two pieces. That much-desired award was now ruined, and no matter how much glue I used to put it back together, it was irreparable.

Over the next few years, I did win a few more trophies to add to my collection. Yet I've only kept the broken one. It's the only one that reminds me that my trophies on earth are temporary and my motivations should be to honor the Lord with a gift He's given me instead getting glory for myself or rising above others.

I still struggle with being competitive in ways beyond athletics. I like to win at work. I like to win arguments. I tend to place value on how many people I can gather at a Bible study or attend an event. I like to win the approval of others. Just writing those things is a painful reminder that my motives in competition can still be impure at times, and I can usually tell when this is the case, as I typically fixate on congratulating—or giving glory to—myself rather than giving glory to the grace of God. And that's the real motive issue behind sinful competition: we take the glory away from the Giver of every good gift. Competition isn't always wrong; it can be fun and healthy in certain ways. But when our heart is set on getting endless glory for ourselves and winning in order to have value, we have found ourselves competing for all the wrong reasons.

What about you? In what ways do you love to win for the wrong reasons? How would you answer Paul's questions in Galatians 1:10: "For am I now trying to persuade people, or God? Or am I striving to please people? If I were still trying to please people, I would not be a servant of Christ."

Just like competition, we live in a culture of comparison. It's easy to see beautiful images and posts on social media and feel like we don't measure up to what the world deems as valuable

or desirable. The constant barrage of advertising and marketing reminds us that if we only had the right clothes or went on the right vacation, our life would be filled with contentment and joy.

Theodore Roosevelt is given credit for the popular phrase, "Comparison is the thief of joy." And what better example of this than the story of King Saul in the Bible? Comparison is what fueled Saul's anger against David. Remember when the women sang in 1 Samuel 18:7, "Saul has killed his thousands, but David his tens of thousands"? Saul's misplaced motive for receiving glory—and not only that, but more glory than David—began a downward spiral toward his diminished rule. His constant comparison of David's success was born out of jealousy and fear as 1 Samuel 18:12 describes: "Saul was afraid of David, because the LORD was with David but had left Saul." Verse 15 adds: "When Saul observed that David was very successful, he dreaded him." This kind of comparison—the kind that doesn't just lead to loss of joy but, in Saul's case, the loss of his sanity and integrity—was all rooted in displaced desires and motives. His motives were veering off course, and his entire life followed.

So are we able to compare ourselves with one another and not be sinful? Perhaps, but it seems like the Scriptures speak to this idea more in terms of *personal examination* than comparison with others. With examination our focus is on what we are doing to honor and please God, whereas with comparison, typically our focus is on the elevation of ourselves. Consider Galatians 6:4–5: "Let each person examine his own work, and then he can take pride in himself alone, and not compare himself with someone

else. For each person will have to carry his own load." Here Paul encourages us to look at our own work as it stands, rather than comparing it to the work of another. In the verse immediately prior to those, Galatians 6:3, he says, "For if anyone considers himself to be something when he is nothing, he deceives himself." Self-serving comparison leads us to consider ourselves better than we are, as we see others either failing to live up to the level we think we've reached (in which case, pride kicks in), or that we aren't as far below someone else (in which case, pride also kicks in). Either way, comparison leads to deception and pride, whereas examination leads to thoughtful reflection and satisfaction in one's work.

Beyond examination, we can also move toward *emulation* (properly done) and even *appreciation*. For instance, Paul tells his readers, "Follow my example as I follow the example of Christ" (1 Cor. 11:1 NIV), and we can't really follow another person's lifestyle without naturally evaluating it against our own. There are plenty of people I see a few steps ahead in the Christian journey and think, *I want to be like her!* This is something we might call a redeemed version of comparison, where I look at another's life against my own; and instead of jealousy or pride cropping up, I experience joy, admiration, and even comfort or instruction in her example. In other words, there is a category for spiritual emulation or even spiritual heroes, so long as we do not idolize them or try to *be* them. Part of discipleship is watching a person's life ahead of yours, trying to align your habits with theirs (Heb. 13:7). Further, Paul compares parts of the body to one another (a hand is not a foot, etc.), but his point is to show the diversity of believers

and the beautiful unity that happens when we all come together, not to elevate one over the other. In this way it is possible for us to turn our head to look at another and appreciate an ear, a hand, or a head, though we are none of those. Noticing our differences is good and helps us appreciate others who are unlike us.

In contrast, while impure motives can be rooted in competition and comparison, the result of impure motives is conflict. James 1:14–15 warns: "But each person is tempted when he is drawn away and enticed by his own evil desire. Then after desire has conceived, it gives birth to sin, and when sin is fully grown, it gives birth to death." All three stages—desire, sin, and death—are seen in the temptation of Eve in Genesis 3:6–22. The desire for the fruit in the garden led to the sin of eating the fruit, resulting in a broken relationship with God and others, and physical death. And inheriting the consequences of her sin, none of us is exempt from this state of affairs. Because of our sin, each of us finds ourselves not just in conflict with other people but in conflict and a broken relationship with God until we trust in Christ to resolve that conflict.

And we must remember that our sinful choices aren't someone else's fault. Remember how Adam responded when God held him accountable for his disobedience? He immediately blamed Eve and even God Himself (Gen. 3:12)! No one "makes" us sin; it's something we choose to do, much like James describes in James 4:1–2. Fights (i.e., sin) come from our own sinful desires. As one commentator says, "Physical, emotional, and psychological desires lead to sinful acts. There is no invisible force that makes

persons sin against their wills. Sin is a consciously-chosen path, not an outwardly determined reflex."[11]

And it's not like conflict stopped with Adam and Eve! No. Not long after sin entered the world in Genesis 3, this kind of conflict keeps on sprouting up as the family tree grows and the generations pass. Remember in Genesis 4 when the Lord disregarded Cain's offering? God reminded Cain in verse 7: "If you do what is right, won't you be accepted? But if you do not do what is right, sin is crouching at the door. Its *desire* is for you, but you must rule over it" (emphasis added). Paul says something similar in Romans 6:12 when he writes: "Therefore do not let sin reign in your mortal body, so that you obey its desires." And we all know the end of the story—Cain gave in to the temptation and acted on his anger by murdering Abel.

The cycle of internal sin resulting in external conflict continued then and continues today. Only by the sacrifice of Christ's death on the cross and His resurrection are we offered the promise of new life and reconciliation with God. Second Corinthians 5:17–21 reminds us:

> Therefore, if anyone is in Christ, he is a new creation; the old has passed away, and see, the new has come! Everything is from God, who has reconciled us to himself through Christ and has given us the ministry of reconciliation. That is,

[11] *CSB Disciple's Study Bible* (Nashville: Holman Bible Publishers, 2017), 1945.

in Christ, God was reconciling the world to himself, not counting their trespasses against them, and he has committed the message of reconciliation to us.

Therefore, we are ambassadors for Christ, since God is making his appeal through us. We plead on Christ's behalf, "Be reconciled to God." He made the one who did not know sin to be sin for us, so that in him we might become the righteousness of God.

Evaluate any conflict you are currently experiencing with another person. Can you examine the root of the conflict, perhaps displaced ambition or an impure motive? Which internal sin, specifically, is starting to result in external conflict? Do you criticize others in order to elevate yourself? When criticized, are you quick to react or become offended or defensive? Consider how you can begin the process of reconciliation when faced with conflict that stems from wrong motives.

Application to Ministry: Developing Pure Motives

We all want better motives in our hearts, don't we? We all want the bedrock desires that drive our behavior to be headed in the right direction! And desires like that take time to develop. So, how do we develop them?

For me, developing pure motives begins each morning as I open God's Word and ask the Lord for wisdom. It is a daily

sanctifying process of asking Him to put my schedule and my plans aside and exchange it for wisdom and conformity to Christ. When our motives are pure, our character, conviction, and desire for wisdom will increase. It's a heart exchange that is shaped by the gospel and displayed as we walk in the Spirit. Going to God's Word is crucial because that's the only place we can find out what God's desires are in the first place. We can't expect to align with them if we don't know what they are.

King David spoke of his motivation in Psalm 40:8: "I delight to do your will, my God, and your instruction is deep within me." David also admonishes in Psalm 119:9–10: "How can a young man keep his way pure? By keeping your word. I have sought you with all my heart." In other words, pure motivation comes from the purifying and sanctifying work of God's Word that dwells richly in our hearts and in our minds. In short, pure motivation is the result of our spending time in the presence of God.

Let's look at an example. We all know that one of God's desires is for us to be "sent out" on mission in our local contexts, sharing His good news with the world. So, how do we get to the point that we desire the same thing and for the right reasons? Isaiah, who encountered the holiness of God in Isaiah 6, was sent out not because of a motive of ambition, but because he had a divine encounter with God. I love how Scarlet Hiltibidal expresses this in her book *Afraid of All the Things* when she writes: "Isaiah didn't do a training camp. He didn't take steroids or attend a seminar on how to be brave. He didn't have to be brave. He simply stood in the presence of God. And being with God, experiencing God, and

being forgiven by God revolutionized how he saw the world and his place in it. He thought he was going to be unmade. Instead, amazing grace. 'Send me anywhere.'"[12] Isaiah's desires were aligned with God's simply because he spent time with Him! What freeing and relieving news for us all—God's Word and presence do the work of changing and developing our motives, not us!

Another way to develop pure motives is to ask for them in prayer. James 1:5 admonishes us: "Now if any of you lacks wisdom, he should ask God—who gives to all generously and ungrudgingly—and it will be given to him." One of my friends likes to remind others that you don't G-E-T unless you A-S-K. The Lord is pleased with our request for good motives and fresh wisdom, as we see in the example of King Solomon. When Solomon became king at about twenty years old, the Lord appears to him at Gibeon in a dream and asks: "What should I give you?" (1 Kings 3:5). Instead of asking for wealth or a long life, Solomon humbly asks for wisdom. Because his request was honorable, God not only gave him wisdom but also gave him much more. We, too, can bank on God's pleasure toward us when we come to Him and ask Him directly for honorable things. Imagine what all our lives might look like if we asked God more for right motives and godly desires than we asked for anything else!

[12] Scarlet Hiltibidal, *Afraid of All the Things* (Nashville: B&H Publishing, 2019), 85.

Pure Motives Lead to Christian Conduct and Thriving Relationships

The biblical principle of reaping what you sow is an important one. When our motives are pure and healthy, there is an overflow of spiritual fruit that impacts not only ourselves but also leads to thriving relationships with others in our local body of believers and our greater community. Galatians 5 reminds us that when we walk in the Spirit, we don't carry out the desires of our flesh. Instead, the result of this kind of purity leads to the fruit of love, joy, peace, patience, kindness, goodness, faithfulness, gentleness, and self-control. And while we can often quote the fruit of the Spirit found in verses 22–23, verses 25–26 speak to the motives: "If we live by the Spirit, let us also keep in step with the Spirit. Let us not become conceited, provoking one another, envying one another." If impure motives lead to comparison, envy, and conflict, pure motives can lead us to loving one another as we walk in the Spirit.

Further, our pure motive is not based on a form of legalism resulting in good works but as chosen vessels God can use. It is what the apostle Paul describes in Colossians 3:12: "Therefore, as God's chosen ones, holy and dearly loved, put on compassion, kindness, humility, gentleness, and patience." Each of these qualities stems from pure motives to live rightly and love one another as they had been commanded.

Pure Motives Lead to Conformity to Christ

As someone who loves driving in the mountains, one of my favorite things to do is to pull out at certain stops and look at the road I've traveled. I can see the twists and turns that got me to where I am. It's not always an easy road—literally or metaphorically—but I'm further along in my journey as I make my way up a mountain. As believers, our sanctification is similar. It's a continual process that should move us to look more like Christ each day, and as we look back, we can see all the ways He's moved us forward toward that end.

As you and I seek to live with proper desires and motivations, we can be reminded of several things Paul said in his letter to the Philippians. He told the church: "I am sure of this, that he who started a good work in you will carry it on to completion until the day of Christ Jesus" (Phil. 1:6). Paul is helping us see that God *will* develop Christlikeness and purity of heart in us. The work is slow and steady, but we can bank on it—He *promises* to make us more like Jesus, and one way He does that is to purify our motives over time.

Paul also teaches us in the entire chapter of Philippians 2 that Christ's pure motive of humility results in His exaltation. As we become more like Jesus, we will likewise grow in our humility and also be exalted by God in the end! Paul's challenge in Philippians 2:3–4 speaks directly to our desires and motivations when he says, "Do nothing out of selfish ambition or conceit, but in humility consider others as more important than yourselves. Everyone should look not to his own interests, but rather to the interests of

others." As our motives change and God removes selfish ambition and conceit, we eventually become more like Jesus, considering others' interests ahead of our own. Finally, Paul challenged us in Philippians 3:10 with: "My goal is to know him and the power of his resurrection and the fellowship of his sufferings, being conformed to his death." Do you see God working slowly and steadily on your desires and motivations, toward an attitude of unselfish ambition? How do you reflect the person of Christ when you live in humility and serve others?

As you evaluate your own desires and motivations, think also about those in your life who know you that deeply. Do you have women in your life who can ask deep questions or who can identify wrongly directed desires or motivations? If not, consider intentionally building those relationships. Conversely, are there women you know well, women who you can identify misdirected desires in their life? Remember, we minister to other women in these four areas—heart, soul, mind, and strength—in order to help them love God rightly. Coming alongside of women and helping them evaluate their desires moves them towards holistic, God-honoring worship.

Conclusion

To be conformed like Christ means we become similar in form, nature, and character. And while we will struggle with our sinful nature that leads to impure motives and desires, each day is an opportunity to look more like Him.

Motivation and desire play a tremendous role in the life of a woman; used rightly, they can draw us closer to our Creator, but when used sinfully, they drive a wedge between us and God and others. As you consider the roles of motivation and desire in your own life, I encourage you to consider replacing your personal ambitions with a focused mission to make disciples of Jesus. May your selfish desires be replaced with pure ones. And may you seek to minister to other women as they align their desires to those of the Lord.

Discussion Questions

1. When was the last time you thought about the topic of desires and motivations? What new insights did you learn from this chapter?

2. Describe a time when your competitive desire was born out of a selfish ambition.

3. How have you experienced an impure motive that led to comparison? What was the result?

4. Was there a verse in this chapter that you need to memorize and apply to your life? Write it down and begin to hide it in your heart.

5. Read Philippians 2:1–11. In what way are you challenged by Christ's humility and exaltation? How can you become conformed to the image of Christ?

INTRODUCTION TO
SOUL SECTION

My soul, bless the LORD, and all that is within me,
bless his holy name. My soul, bless the LORD, and
do not forget all his benefits. He forgives all your
iniquity; he heals all your diseases. He redeems
your life from the Pit; he crowns you with faithful
love and compassion. He satisfies you with good
things; your youth is renewed like the eagle.

—PSALM 103:1–5

One of the things that makes us unique as image bearers of God is that God breathed life, breathed a soul, into us at creation (Gen. 2:7). Additionally, we have the ability to have a relationship with our Maker. These two realities are fundamental and essential truths: we are unique as women and men because we have a relational and an immortal soul—something that other living things in the created order do not have.

In this section we'll explore how we can minister to one another's souls. In particular, we'll discuss a woman's relationship with the Lord and her spiritual disciplines, drawing out some potential areas of struggle as well as a number of ways we can minister to our sisters and brothers in those areas.

6

RELATIONSHIP WITH THE LORD

Tara Dew

Trust in the LORD with all your heart and lean not
on your own understanding; in all your ways submit
to him, and he will make your paths straight.

—PROVERBS 3:5–6

Introduction

In Christian accountability groups, we often ask one another: "How's your relationship with the Lord?" Desiring to find out the state of our souls, this question often receives a litany of responses. Some might define their relationship with God as healthy, by describing their time in prayer or in reading the Bible. Yet others might drop their heads and mumble, "I've kind of gotten into a slump with my quiet time." Sound familiar? Maybe you, too, could have answered the question in similar ways during different

seasons of life. But does our quiet time directly relate to our relationship with the Lord? Does checking off the boxes of reading our Bible or sharing our faith somehow make us more godly?

When considering ministry to women and their relationship with the Lord, we are quick to come up with a formula to become better Christians, better wives, better workers, better mothers, better roommates, better friends, better ministry leaders, etc. You get the gist. It's like Christian "self-help." In order to have a better relationship with the Lord, you just need to work harder. Spend more time in the Word. Get up earlier and pray longer. Teach a Bible study. Have an accountability partner. Share your faith. And we use these spiritual disciplines as a means to gauge the health and vitality of our relationship with the Lord.

Now don't get me wrong. Spiritual disciplines are important. As a matter of fact, the entire next chapter will focus on these! However, this chapter seeks to shine a new light on what it means to have a vibrant relationship with the Lord. Instead of focusing specifically on *disciplines*, we will examine what the Bible says about our *souls* and their impact on our relationship with God. The Bible speaks often about the importance of our souls and what it means to care for them; namely, seeking God first and staying in step with his Spirit. These are the ways we should measure our relationship with the Lord. Specifically, we will look at the importance of abiding with Him, living in His presence, and walking in His ways. We will identify common areas where women struggle, and then conclude the chapter with

a few application points, helping us tangibly prioritize our relationships with the Lord.

What Does the Bible Say about Our Souls?

Like many Christians, you might have a hard time defining the soul. In fact, there is much discussion in Christian circles today about this part of our identity. Some deny that we have a soul and say that we are merely physical bodies. Others say that we are only our souls that just inhabit a physical space. However, the truth is, human beings are holistic. We are both body *and* soul. This is especially important to know when ministering to women. Instead of ministering exclusively to one or the other, we must be careful to serve *both* the physical realities in their lives as well as the soul-level realities. While chapter 10 focuses on the importance of caring for the physical side of things, this chapter helps us give special attention to caring for the soul.

So, what exactly is the soul? Instead of giving us a clear-cut answer, the Bible is a bit vague, or perhaps mysterious, about the soul. Indeed, though we in the West love a good succinct definition, the Bible doesn't always speak in those terms. Sometimes the soul is mentioned with the spirit. Other times it is mentioned with the heart. Some say the soul, heart, and spirit are all interchangeable ways of referring to the immaterial part of humans, or the "inner man." But some say it is possible that the soul can be distinct from both of these, because all three are mentioned separately in passages such as Hebrews 4:12: "The word of God

is living and effective and sharper than any double-edged sword, penetrating as far as the separation of soul and spirit, joints and marrow. It is able to judge the thoughts and intentions of the heart." Here the Word of God is described as having the ability to penetrate to the deepest level of our inner self, hitting on something that might otherwise stay hidden, and some theologians say it can even distinguish between the soul, spirit, and heart.

The jury is still out on this question, but if the soul *is* different from the spirit and the heart, then what might we know about it? The Bible seems to imply that it is the deepest part of us that is spiritual and hidden, yet it drives our intentions and motivations. Our souls are created to seek and long for communion with God. It is the thing within us that thirsts for God, just as our body thirsts for water. Psalm 42:1 (NIV) says: "As the deer pants for streams of water, so my soul pants for you, my God." Similarly, Psalm 63:1 (ESV) says: "O God, you are my God; earnestly I seek you; my soul thirsts for you; my flesh faints for you, as in a dry and weary land where there is no water." The soul is the spiritual part of our being that directs the intentions and motivations of our lives. Our souls were created to be focused on God, desiring and seeking Him above all else.

But because we live in a fallen world, our souls do not always point toward God or seek Him as they should. For the unbeliever, that means the soul is enslaved, unable to come to a restored relationship with God apart from the saving work of Christ. For believers, our soul—along with every other component of our identity—is saved to God and is no longer a slave to sin.

However, because it is still in the process of being sanctified, our soul can still experience temptation to sin and wrestle with it, as Paul describes for us in Romans 7:14–25.

To correct ourselves when we start to feel the pull of that temptation, we can urge our souls to reorient toward God. Psalm 42:5 says: "Why, my soul, are you so dejected? Why are you in such turmoil? Put your hope in God, for I will still praise him, my Savior and my God." In times when we are discouraged or depressed, we have the ability to redirect our souls in praise to God. We can refocus our souls to long for and bless the Lord. Consider Psalm 103:1–2, 22, which says five times for our souls to praise the Lord: "My soul, bless the LORD, and all that is within me, bless his holy name. My soul, bless the LORD, and do not forget all his benefits. . . . Bless the LORD, all his works in all the places where he rules. My soul, bless the LORD!" The Bible describes the soul as the part of us which should long for the Lord and desire to bless Him. In our lives we must direct and redirect our soul to Him.

The Role of the Soul in a Woman's Life

The soul is the innermost part of the believer that should be focused on seeking God. Just as the needle of a compass will continually point to the north, our souls should directionally point us toward God. Our longing for Him should be greater than anything else. Our focus should be on Him rather than the things of

this world. Once our faith has been put in Christ, by the power of the Holy Spirit, this can become true of us.

So, how does the soul impact a woman's life? How do our souls influence our relationship with the Lord? And how can we distinguish if our souls are leading us in the right direction or they are in need of correction? With the help of the Spirit, we can say for certain that our soul is truly directing us toward God, like a compass, if we see these four evidences below. If our soul is in the right place, the following things will be evident in our own lives and in the lives of any woman we are leading:

1. We will be seeking the Lord in our life and decisions. If our souls are seeking God continually, then our relationship with the Lord will be vibrant. Many passages throughout Scripture describe this seeking, but two in particular come to mind. Consider Deuteronomy 4:29, which says: "You will search for the LORD your God, and you will find him when you seek him with all your heart and all your soul." God desires to be found by us. He is a relational God, but we must seek Him with all our heart and soul. Similarly, Matthew 6:33 commands us to "seek first the kingdom of God and his righteousness, and all these things will be provided for you." If our soul is directed properly toward the Lord, then we will be seeking Him above everything else in our lives and decisions.

Think about your own life or the lives of those women you minister to. Are you seeking God above everything else? Is He truly guiding your decisions, or is something or someone else guiding them? If you find that your decisions are ultimately being

made by your preferences, your peers, your fears, or otherwise, what would it look like for you to correct your soul and reorient it toward God?

2. We will love God supremely. If our soul is focused Godward and our lives are seeking Him, then love and worship are the natural by-products. Deuteronomy 6:5 is perhaps one of the most quoted and familiar passages: "Love the LORD your God with all your heart, with all your soul, and with all your strength." We are commanded to love God with all of our beings, but especially our souls. Similarly, Deuteronomy 10:12 asks what is required of followers of God. Moses answers: "And now, Israel, what does the LORD your God ask of you except to fear the LORD your God by walking in all his ways, to love him, and to worship the LORD your God with all your heart and all your soul?" If love and worship for God are pouring out of our lives, then our soul is clearly in the right place. If love and worship for God are not pouring out, then we can be sure it's time to correct our soul in some way or another.

Think about your own life and the lives of those you minister to. What pours out most? What does that tell you about the state of your (or her) soul?

3. We will abide with Christ and practice living in the presence of God. If our souls are continually pointing us toward the Lord and desiring to love Him above all else, then we will abide and live in the presence of God through our Savior Jesus Christ. In John 15, Jesus describes this dwelling with God, using an analogy of the vine and the branches. When our souls are seeking the

Lord, we are like the branches that are connected to the Vine—Jesus. We are connected to our source of joy, strength, and love, and we are able to obey Him as we were created to do. Living in this presence of God will renew our souls (Ps. 23:3). In addition, it will calm and quiet our souls (Ps. 131:2), trusting Him to care for us as our heavenly Father.

Again, what about the souls of yourself and those you lead? Do you see vibrance and fruitfulness, or do you sense brittleness and need for renewal? Do you sense calmness, trust, and quietness, or do you sense restlessness, distrust, and noise? What does this reveal about the condition of your (or her) soul?

4. We will rest in the Lord. As we abide with the Lord, seeking to love Him supremely, we find our rest. Psalm 62:5 describes this rest and hope that come from the Lord alone: "Rest in God alone, my soul, for my hope comes from him." Life can be stormy, and circumstances might seem bumpy. But this rest and hope will anchor our souls (Heb. 6:19).

Can you sense rest, security, and an "anchored-ness" in your soul and the souls of those you lead? If not, why? What would help reorient your soul back to this place?

Common Areas of Struggle

In the introduction, a common accountability question was posed: "How is your relationship with the Lord?" Maybe it could be asked another way: "How is your soul?" Like a compass, our soul should be directed toward our loving Father. But, if the focus

and direction of our soul is pointed toward something other than God, we can easily get off track. In contrast to the four markers of a vibrant soul and relationship with the Lord, let's explore three common areas of struggle.

First, if our souls are not seeking the Lord, our desires begin to be misplaced. We will chase after the things of this world. Like a fish follows after a shiny bait, Satan tempts us into thinking other things will satisfy us. Instead of seeking the Lord, we will seek fame, power, money, possessions, sex, etc. If we are not careful, these longings will lead to a misplaced identity and then to idolatry. We begin to find our satisfaction in that which is temporary and fleeting. But remember: we were not made for these things. We were made for God. Our souls were made to seek God first. What are the distractions in your life that always look "shiny" to you? In difficult spiritual seasons, what is the one thing your soul typically seeks first instead of God? What about the women you lead?

Another area of struggle that follows from not seeking the Lord is that our soul misses out on the vitality God's presence offers us. It is as though the branch cuts itself off from the Vine, saying, "I no longer need you." How arrogant and prideful! When we remove ourselves from His provision and care, we set ourselves up for temptation and sinful desires. First Peter 2:11 says that these "wage war against the soul." It is a slippery slope, beginning with a desire which leads to sin and ultimately death (James 1). Indeed, a branch removed from a vine may last for a few moments on its own, but it will eventually wither away to death, as it is no longer connected to a source of vitality. Are there any places you

or those you lead feel "withered"? In what ways can you connect back to the Vine?

Finally, when sin begins to take over and our souls are no longer in communion with the Lord, pointing our lives toward Him, we do not have peace. The trappings of this world leave us lonely and always striving for more. Instead of drinking water from a fresh stream, sin is like drinking salt water: it satisfies for a moment but only leaves you thirstier. There is no refreshment or rest. No peace. No anchor for our souls. Matthew 16:26 (NIV) describes the foolishness of seeking the things of this world: "What good will it be for someone to gain the whole world, yet forfeit their soul?" Our souls are meant for God. Seeking anything else first forfeits not just our peace but our souls. Where in your life (and the lives of the women you lead) do you sense a constant striving? In what ways are you lonely or exhausted? What might help you enjoy deep communion with God again and enter into His rest once more?

Application to Ministry

So, apart from the internally focused questions mentioned thus far, how can you outwardly apply all of this to the women in your care? What are some practical ways for you to care for their souls? If you sense that their souls may be in need of reorientation, how can you nurture their relationships with the Lord, helping their compass point north again?

First, make sure you keep the gospel at the forefront of your ministry. Remind your ladies often that God saved their souls from death into a vibrant and eternal relationship with Him (James 5:20). Encourage them to remember who they were before Christ, to pray that God would restore to them the joy of their salvation, and that God alone would be who they seek, rather than the trappings of this world.

In addition, teach your ladies to prioritize their relationship with the Lord in their regular rhythms of life. One way to do this is to teach them what regular repentance looks like. Healthy habits of repentance are vital to keeping them in the presence of the Lord, as it uproots sin and allows them to abide with Him (James 1:21). Another way to do this is teaching them that reorientation is a daily thing. We all must daily reprioritize the Lord in our thoughts and desires for our souls to be renewed (2 Cor. 4:16). It won't "just happen." We all have to fight for it.

As we all can attest, women are busy. There is much that pulls at our time and attention. Many relationships, responsibilities, and requirements fill our days. Therefore, in addition to a daily "reset," it is important for women to take extended time away from their normal responsibilities to reset their souls and reprioritize their directional focus. Matthew 11:28–30 is a beautiful promise of the Lord: "Come to me, all of you who are weary and burdened, and I will give you rest. Take up my yoke and learn from me, because I am lowly and humble in heart, and you will find rest for your souls. For my yoke is easy and my burden is light." When we allow women to retreat and reset, they are able

to find rest for their souls in the Lord. Annual women's retreats are one vital way we can help women take the extended time with God they need to care for their souls.

Finally, in accountability circles, make sure to ask questions that go beyond the checklist of spiritual disciplines to investigate the true state of the women's souls. (Feel free to use the questions mentioned in this chapter, or take time to come up with your own!) As we lead other women, we "keep watch over [their] souls as those who will give an account" (Heb. 13:17). Caring for their souls, prioritizing their relationships with the Lord, and continually redirecting their priorities toward Him are necessary tasks for any shepherd.

Conclusion

In his third epistle, the apostle John greets his friend with an interesting statement: "Dear friend, I pray that you may enjoy good health and that all may go well with you, even as your soul is getting along well" (3 John 2 NIV). So often we focus on the outward physical signs of wellness, or even the check-listed formula of spiritual disciplines to determine our soul's health. But what if we gauged the health of our lives by our relationship with the Lord? What if we gauged our overall health with the health of our souls? Our soul is the innermost, hidden, spiritual facet of our beings that points us toward the Lord. It is the motivator for seeking Him, loving Him, worshipping Him, and resting in His presence. A right relationship with the Lord allows us to stay

in step with His Spirit, avoid the sinful desires of the flesh, and rightly order our priorities and lives. So, my friend, how is your relationship with the Lord? I pray that all may go well with you, even as your soul is getting along well.

Discussion Questions

1. Have you been tempted to gauge your relationship with the Lord by using the spiritual disciplines as a checklist? Instead, how should we determine the spiritual health and vitality of our relationships with the Lord?

2. After processing through some of the other questions in this chapter, in what ways have you neglected your soul? In what ways did this affect the rest of your life?

3. Do you take time to "reset" your soul, either daily, weekly, monthly, or yearly? Are there times that you are just still before the Lord, prioritizing your relationship with Him above all else?

4. What are some practical ways you abide with the Lord and stay in step with His Spirit? What are some new ways you could do this?

5. Think about the women you minister to—where on the spectrum of health are their souls right now? How might God be convicting you to better care for their souls in this upcoming season with them?

7

SPIRITUAL DISCIPLINES

Amy Whitfield

Have nothing to do with pointless and silly myths.
Rather, train yourself in godliness. For the training
of the body has limited benefit, but godliness is
beneficial in every way, since it holds promise for
the present life and also for the life to come.

—1 Timothy 4:7–8

Singer-songwriter Andrew Peterson wrote a letter to his thirteen-year-old son in which he talked about the challenges of growing up. The tension between the body and the soul was clear as he communicated how our life fits into a grander story:

> But one of the grand things about growing up,
> I've learned, is that you're already ancient. Your
> soul, whatever the "soul" is, will live forever in
> Christ, and God exists outside of time. That's

a crazy thought, isn't it? God looks at us and sees the beginning and the end at once, kind of like a song or a story. When you hold a book in your hand, you're holding that character's whole world—the terror, the joy, the lostness, and the final good ending. But if you think about it, the character in the story doesn't see the ending, doesn't know his story is something that can be held in one hand. The character is feeling whatever he's feeling when you read that sentence. But the reader, a little bit like God, can flip to the end and see how it all works out. Maybe that's how God beholds our lives. He sees the ending, the middle, and the beginning as one good story. Right now, you're thirteen and wondering where you're going to work, who your friends will be in twenty years, where you'll live, who you'll marry, what your kids will be like. But in some mysterious way, God knows all those answers even now. Every day is another page in that story, and you can't know how it's all going to turn out, just like riding a roller coaster for the first time—except that because of Jesus, because he has made you his son, you can embrace all the twists and turns with joy because you can be confident that he built the ride and loves you more than you can presently know. You will survive until the end of

your life (whenever he has decided that is), and
then you will continue on into the next book of
your life in Christ. That's Heaven.[13]

This life we are living in can be a challenge, even when we
know the ending. As we live in the "already-not yet" reality of the
Christian life, it is easy to wonder how we will get from point A
to point B, and all the way to the end. The good news is that God
has promised to work inside us as we walk one step at a time with
Him. Living by faith is a daily decision, and spiritual disciplines
play a role in shaping that faith as we move through our stories.
Just like with a book, even when we know the ending, the middle
matters tremendously.

Practically speaking, spiritual disciplines are things like con-
sistent Bible reading, daily prayer, or regular times of fasting, to
name a few examples. They are practices we intentionally build
into our lives—practices that, if repeated enough, create habits.
And, in turn, those habits can help us become more like Christ
over time, aiding in our spiritual formation. Spiritual disciplines
move us along in our stories and mature us.

Yes, developing and practicing spiritual disciplines take energy
and effort. But don't let that fool you into thinking this means you
are pulling yourself up all on your own, that your growth in Christ
is ultimately something you can achieve in your own strength,
or that a healthy spiritual life is guaranteed by completing these

[13] Andrew Peterson, "You'll Find Your Way," January 15, 2013, The
Rabbit Room, accessed May 3, 2021, https://rabbitroom.com/2013/01/youll
-find-your-way-a-letter-and-a-video.

things each day. No, only God can ultimately grow us up into the image of His Son, and plenty of people go through the motions of spiritual rituals while remaining far from God (Isa. 1:10–17; John 5:39; Matt. 15:1–9; 23:23; Rev. 2:1–4). Instead of viewing spiritual disciplines as a way to earn God's favor or guarantee spiritual health, view them instead as opportunities to form habits that place your trust in the Lord to make you into the person He has saved you to be. God is the change agent; spiritual disciplines help us come to Him.

This chapter will walk through a brief discussion of the Bible's take on spiritual disciplines along with the role they play in our lives. Then we'll spend time exploring various disciplines we as women can put in place during this "middle" part of our stories, as we move toward the happy ending of complete Christian maturity God promises us.

What Does the Bible Say about Our Spiritual Disciplines?

Paul wrote to the church at Philippi: "Therefore, my dear friends, just as you have always obeyed, so now, not only in my presence but even more in my absence, work out your own salvation with fear and trembling. For it is God who is working in you both to will and to work according to his good purpose" (Phil. 2:12–13).

What does it mean to work out our own salvation? Paul seems to be saying that salvation isn't just a thing we receive and forget about; it's something we flesh out in our daily life. It's something

we *walk in,* something that works itself into our everyday endeavors. Many refer to that process as sanctification, but a plainer way to speak of it is "growing in Christ." As we walk in His ways, we become more like Him. So, how can we walk in the ways of Jesus? One way is through practicing spiritual disciplines.

Now, before we dive into *spiritual* disciplines, we should probably talk about the word *discipline* itself as a starting point. In our culture the word *discipline* sometimes carries a negative connotation. We see receiving discipline as a bad thing, like a punishment. Even when we talk about self-discipline, we look at it as depriving ourselves of something, or making ourselves do something. We talk about discipline when we go on a diet or when we join a gym and don't allow ourselves to take a single day off. Even the way we describe "cheat days" indicates that discipline is punishment, and breaking from discipline is reward.

Unfortunately, some approach sanctification in the same way, unintentionally importing the world's view of discipline into their walk with God. If we genuinely want to grow in Christ, though, we should adopt the Bible's view of discipline instead, which paints discipline in a much more robust light! Sometimes Scripture paints it as difficult, and other times it paints it as positive. Yes, negative consequences are a type of discipline from the Lord when His people misstep. We certainly see the rod and the staff in His hand as He helps His people back on the right path when they have strayed into danger. But rewards are also a disciplinary tool we see in His hand many times, too. God disciplines us through positive reinforcement all the time! For instance, God

blesses those who obey (Luke 5:1–11; Deut. 28:2). Whether through punishment or reward, God's goal is to help us, guide us, and keep us on the right path.

As for self-discipline, Scripture does not paint this darkly; it actually applauds a person who is able to control herself (or himself). In fact, the Bible paints self-discipline as *freedom*, not deprivation, as it is evidence that a person is not a slave to her flesh, her appetites, or her impulses. A self-disciplined person proves that humans really are the crown of God's creation, different and above animals, which can only make choices based on impulse, instinct, and appetite. As the Bible sees it, instead of being mastered by her passions or impulses, a disciplined woman is actually the master over those things, equipped by God with the control and wisdom to tell them what to do. In short, a disciplined Christian is not held back; she is *free* from being controlled by world, the flesh, or the devil.

Guidance, safety, and freedom in the Lord. These things are what biblical discipline in general is all about. And the same is true for spiritual disciplines; in fact, spiritual disciplines are the primary means by which we get to enjoy these things! As you can imagine, though, it is hard to drown out the noise of the world that constantly distracts us. We all want God's guidance and safety. We all want to stay on the right path. We all want freedom from sin and mastery over the things that used to enslave us. But to go from *wanting* these things to actually *enjoying* them requires training and living our life before the Lord. An athlete trains daily, sometimes through pain and difficulty, but she is striving for a

greater goal. She may experience challenges or even unpleasantness, but discipline is a means to attain something she desires. For the believer, our goal is not only the guidance, safety, and freedom we need in this life to keep walking faithfully with God but also eternal life with Christ. After sharing multiple examples of those who displayed faith over the spans of their lives, the writer of Hebrews says: "Therefore, since we also have such a large cloud of witnesses surrounding us, let us lay aside every hindrance and the sin that so easily ensnares us. Let us run with endurance the race that lies before us, keeping our eyes on Jesus, the pioneer and perfecter of our faith. For the joy that lay before him, he endured the cross, despising the shame, and sat down at the right hand of the throne of God" (Heb. 12:1–2). Look at that Savior—the One who knowingly endured the cross of Calvary for us. The One that same cross couldn't even hold down! The One who walked out of the grave and is sitting next to God the Father right now. We can certainly run our race with discipline in these "middle" years of our story when this is the great God we will greet once we finish!

Yes, we must live our lives before the Lord and train our minds to have an awareness of who this great God is and what He is doing. But how can we train our minds in this awareness? By believing the story is real (and revisiting it when we forget)!

We believe the universe was created by one God in three persons and when man's relationship with Him was broken, He sent His Son to live on earth—fully God and fully man. We believe He was sent—and also that He willingly chose—to die for our sins and rise again on the third day. We believe He went to heaven and

is coming back for us one day. And we believe we'll enjoy eternal life with Him in a new heaven and earth that is finally free of sin and death and evil. This story seems crazy and outrageous to a watching world. But it is our story. And it's true.

Our tendency is to forget that the story is real, isn't it? And when we forget the story is real, we tend to stop living in light of it. What was Adam and Eve's great sin? It was not believing God. That's why they did what they did.

Forgetting the story, or perhaps not believing the God of the story, will land us in the same ditch Adam and Eve fell in. Instead of growing in the light, we will shrivel in the dark. So what is the answer for women like you and me who want to grow in the light, yet tend to forget our great God and His story? Do we pull ourselves up by our bootstraps and figure out how to navigate this world on our own? No. Among other things, we practice spiritual disciplines. Why? Because here's the often-forgotten superpower of spiritual disciplines—*they help us remember again.*

The Role of Spiritual Disciplines in a Woman's Life

Spiritual disciplines are, according to Jerry Bridges, "instruments of grace."[14] He uses the illustration of weight-lifting. The weights are instruments, just as disciplines are. Weights provide resistance; they add something. They don't work if they aren't picked up, but the instruments themselves lead to change.

[14] Jerry Bridges, *The Discipline of Grace* (Carol Stream, IL: NavPress, 2006), chap. 10, Kindle location 1763.

This is an articulate definition, but I prefer the way Carolyn Arends describes them. Arends oversees the Renovare Institute for Christian Spiritual Formation. When talking about the purpose of spiritual formation, she gives the simple reason that "we become like what we hang around."[15] It shouldn't surprise us to discover that as we spend more and more time with Jesus, we become more like Him! The closer we get to Him, the more we begin to think and speak like Him because our inner person is being transformed to love what He loves, hate what He hates, and value what He values. Arends goes on to say that "training is better than trying—cooperation with God is an invitation to train. God is the transforming party, but we are cooperating."[16] The promise of God is that we will look like His Son. As we draw near to Him, we aren't striving as much as we are cooperating with Him, trusting Him to work in us and change us.

Paul put it this way to the Corinthians: "We all, with unveiled faces, are looking as in a mirror at the glory of the Lord and are being transformed into the same image from glory to glory; this is from the Lord who is the Spirit" (2 Cor. 3:18). Spending time with Jesus is the means by which the Holy Spirit works in us to make us more like Him. Through Christ, and by the power of His Spirit, we are being transformed. And as Paul notes, that transformation comes not by our own power but by His. We must

[15] Carolyn Arends, "The Arts as Allies in Spiritual Formation," Lecture (Nashville, TN: Hutchmoot, October 2019).

[16] Ibid.

spend time with Him, then, in order for Him to work in us and transform us into His image.

We often fight against the concept of spiritual disciplines because our natural bent is to want to "do life" on our own. When these disciplines start to feel performance based, the pressure becomes too great, and they become easier to cast off. We think they complicate our lives, but they don't. Donald Whitney argues that they clarify our lives "by simplifying our communion with God. He hasn't left us to find our own ways to Him. We don't have to wonder how to meet with the Lord and experience Him. God Himself established paths—such as Bible intake, prayer, worship, service, evangelism, fasting, silence and solitude, journaling, and fellowship—which make our spiritual walk with Him simpler and more satisfying."[17] Though we won't tackle all of the ones Whitney does, we'll consider a few and add a handful of others below. But first, let's talk about what holds us back from walking down these God-given paths that help us commune with Him.

Common Areas of Struggle

The first thing that holds many women back from enjoying spiritual disciplines is feeling overwhelmed. When we look at all the habits we are trying to build, we can sometimes feel like they are simply so big we don't know where to start. Along a similar

[17] Donald Whitney, *Simplify Your Spiritual Life* (Carol Stream, IL: NavPress, 2003), 145.

vein, we think we have to do all of them all the time. We tell ourselves that we have to do it all to be a "good Christian," rather than focusing on one at a time. But we *don't* have to do it all; as we walk in step with the Spirit, He will usually pinpoint one or two specific things He is convicting us to work on in this leg of the journey. And all we have to do is obey, one step at a time.

For many of us, another thing holding us back is the busyness of life. It takes over sometimes, and we don't know how to fit these disciplines into our schedule. I don't think I've ever met a woman whose life isn't full; all of us have loads of responsibilities, whether they are family obligations, work responsibilities, or relationships that take work to maintain. We are all busy. Adding in an extra to-do item isn't something we often like to do. Here it helps to recall that spiritual disciplines aren't to-dos. Remember? *They are ways to help us remember the story.* Yes, life is busy, but we are far better at the details of everyday life, and glorifying God in them, when we remember the story of who God is and what He has done. Instead of taking away time or energy from your task list, spiritual disciplines actually help you do the "busy" stuff with the right mind and heart!

Another one of the biggest barriers to spiritual disciplines is spiritual warfare. The enemy would like nothing else than to give us reasons to avoid spending time with Christ. When we spend time with God, uninterrupted and life-giving time with Him, we desire to do it more and we desire that others know Him. But that's an affront to our enemy; his desire is that we forget God, so time with Him is threatening. Here it helps to remember that the

act of prioritizing spiritual disciplines has cosmic, kingdom-wide effects. Imagine what the world would look like if all Christians everywhere chose to engage with God deeply and daily, braving every single day with a fresh memory of the story they are living inside, ready for battle and for victory. The enemy would have far less ground to take!

Lastly, we can all admit that sometimes we just don't want to practice spiritual disciplines. It takes time to read, it takes time to pray, and many times we feel we don't reap tangible benefits. Ultimately, these are desires of our flesh, and they are sinful. If we find ourselves in this embarrassing place, the unbelievable truth is that God's arm is not too short to reach us! If we come to Him in honesty and confess that our heart is in all the wrong places, He will change us. Yes, even on the desire level. It's what He does. If you find yourself here, keep coming to Him anyway. Keep telling Him the truth. Keep seeking Him diligently, even in the embarrassing moments, for He promises to show up for you (Jer. 29:13; Deut. 4:28–29; Prov. 8:17).

When we find ourselves faced with reasons not to pursue spiritual disciplines, we have to remember the promises of God—that He is at work in us to transform us. It is Him working in us, not us working in ourselves, to change us into Christ's image. And when we participate in spiritual disciplines, we are showing up to be changed.

Application to Ministry

So now that we know the value of spiritual disciplines and we are aware of the struggles that may try to hold us back from them, what are some specific examples of them? Let's begin by saying there is no set list somewhere, like a checklist or a book of rules. Yes, there are certain things that we are called to do in Scripture—for example, reading God's Word and praying. But many other things have been identified as spiritual disciplines that are not all required every minute of every day. We have to see the end game—knowing Christ and being transformed to His image—and then determine what instruments we will use and how. Arends casts the net wide to say that a spiritual discipline is "any practice that helps you cultivate friendship with Christ."[18]

This means a number of things can assist you in your in growth, and they vary by person. Perhaps for one person a regular hike can serve that purpose while for another person it comes through writing an essay. These experiences can be personal and different during various seasons of life.

Some spiritual disciplines, however, are recommended and beneficial for all believers in virtually every season of life, as health allows. They are not tests of salvation. Our salvation is based on Christ alone, not on a checklist. But we are called to pursue growth, and these habits aid us in that growth. Here are some examples of these spiritual disciplines.

[18] Arends, "The Arts as Allies in Spiritual Formation."

We must also remember that these disciplines, while personal, shouldn't be done in isolation. We should study the Bible together, pray together, speak the gospel regularly to one another, etc. As one member of the body grows, it impacts the others, and we find great encouragement as well as helpful models in one another when we practice these disciplines together. It leads us all to love God more fully when we practice these in community. Here are some examples:

Bible Study

Studying the Bible can be daunting, especially for new believers. I have met so many women who are new to the faith, and they are overwhelmed as they approach the Word of God. Despite any sense of anxiety, we have to remember that God's Word brings life and not death. There is no required amount of reading. We can meditate on one verse for several minutes, or we can read an entire book in one sitting. The key is to begin somewhere and go to the Word, and a myriad of Bible reading plans can guide you in your study.

Finding the perfect reading plan is not the ultimate key to spiritual growth, as if this will unlock everything. No matter the plan, God's Word is perfect, and every time we approach it, we gain from its richness. The plan we use is not a silver bullet or a guarantee that we're spiritually healthy; it's just a way to organize our time so that we maximize what we learn and so that we aren't overwhelmed. We want to use those plans as a tool so that we

are reading Scripture because it is God's Word, and taking in His Word is how we can know Him. We serve a God who speaks, and we want to hear what He has said.

To hear what He has said, reading the Word should be a priority as well as studying it, as reading and studying are different things. To dig deeper into the verses and get the most out of them, we must move from reading to studying, which can be done through a simple three-step method known as inductive Bible study. The three steps are: observing the text (writing down observations and asking questions about what you have read), interpreting the text (summarizing the meaning of the text in a few simple sentences), and applying the text (asking how you may apply what you have read in your life personally and committing to those applications).

Another option is to study supplemental works along with Scripture, even in incredibly basic forms. Commentaries, theology books, devotional books, and Study Bibles notes cannot be a substitute for reading Scripture itself, but they can help us understand and apply it.

Prayer

This discipline can be a challenge for so many, including me. In a world where so much is going on, quieting our minds to talk with God can be difficult. Not knowing what to say can make us afraid to approach His throne. But God tells us that we can do just that because of the sacrifice of His Son. Because He paid the

penalty for our sin, we can come to the Father with any concern, request, burden, or thought. So often we forget that one of the primary things Jesus was securing for us on the cross was our ability to talk to God! Why would we not avail ourselves of this? We have been given unhindered access to the Father, and so we cannot let fears or lack of experience stop us from continuing to use this access as we approach Him in prayer.

If you don't know where to begin with the discipline of prayer, there are many resources. The first place to start is to look to the Bible for examples of prayers that we can even read as our own prayers. The psalms are great tools for this, as well as the prayer of Hannah in 1 Samuel 2 or the song of Deborah in Judges 4. Another great option is to find a prayerful woman we know and ask for mentoring in this area. Learn from people of faith who have gone on before us, and watch what they do. Additionally, a number of resources on prayer can be helpful in knowing where to begin or how to organize your prayers:

> *Prayer* by Tim Keller
>
> *Kingdom Prayer* by Tony Evans
>
> *A Praying Life* by Paul Miller
>
> *Fervent* by Priscilla Shirer
>
> *Prayer* by John Onwuchekwa
>
> *The 28-Day Prayer Journey* by Chrystal Evans Hurst
>
> Echo Prayer App

Scripture Memory

Scripture memory is a spiritual discipline that is both underrated and overrated. It is underrated in that too many don't do it and are afraid to try. We see it as something children do in Sunday school, not something for us to incorporate into our own rhythms. But it can also be overrated when all the emphasis is placed on perfection and memorization for its own sake. This discipline is not about winning a contest, getting more stars than anyone else, or having bragging rights for how much you can recite. Instead, the discipline of Scripture memory should be about putting God's Word in our hearts so that it quickly comes to our minds and lips in the moments we need it most.

If you're anything like me, there have been many times of anxiety or great temptation in your life when what you need most is to know what God thinks. Or perhaps you've faced some evangelistic moments when you were searching for the right words to share with a friend but had a hard time finding them in your efforts to share the gospel. As it turns out, hiding God's Word in our heart brings these words to mind. It tells us immediately what He thinks. It allows us to hear His voice through what we know He has said. Memorizing Scripture is a mental discipline. It takes work. But it is worth the work because it allows us to keep His Word with us as we go about our days.

It is important to have a plan and tools for Scripture memory. Some of the best options are:

The Bible Memory App
Fighter Verses
Topical Memory System

Journaling

Journaling is a discipline that comes naturally to some and less so to others. I love to journal and have done so for years, although I go through dry seasons. But writing out your thoughts can be a way to reflect on them thoroughly. I often journal about something that I am struggling with deeply. The act of writing it out helps me slow down and process my thoughts, often leading me to hope by the end of my entry.

If you aren't sure where to begin, consider guided journals or in-depth prayer journals. You can treat your journal as a diary where you log something every day. You could journal at a slow and steady pace, writing on sporadic days as you are able to devote time. You could compose essays on your laptop for your own reflection. Whether you are free-writing or developing an argument, journaling allows for expression and reflection.

Preaching the Gospel to Yourself [19]

One of the biggest keys to weathering the ups and downs of life is to remember the reality we live in. Doom and gloom aren't

[19] The concept of "preaching the gospel to yourself" is now a phrase circulating far and wide in evangelical life, and can be found in countless

our story; victory and triumph are. This doesn't mean we don't suffer. It doesn't mean everything is happy all the time. It does mean, though, that we are able to see the landscape of God's kingdom and remember our place in it. And one great way to do that is by preaching the gospel to yourself. As we preach truth to ourselves, that truth becomes ingrained in our hearts and minds, which eventually finds its way into our words and actions (Luke 6:45).

Sometimes, in the midst of struggles in life, we have to remind ourselves of our own identity in Christ, and that means we tell ourselves the story of the gospel. This may require some supplementary resources, which can be interspersed throughout the day. I like to listen to music that sings the gospel, read books that tell the gospel (even children's books!), and meditate on Scripture passages that communicate the gospel concisely. There are a number of tools for this, but here are some of my favorites:

In Christ Alone (album) by Keith and Kristyn Getty
A Gospel Primer for Christians by Milton Vincent
The Promises of God Storybook Bible by Jennifer Lyell
The Story Film (thestoryfilm.com)

sermons and articles, but I originally came across this concept through author Jerry Bridges in chapter three of his book *The Discipline of Grace* (Colorado Springs: NavPress, 1994).

Corporate Worship

Participating in corporate worship is a matter of discipline. We weren't meant to walk alone but, rather, to do so in community (Heb. 10:25). As Ed Stetzer has often said, it isn't that God's church has a mission but rather that God's mission has a church.[20] God designed His mission to be done together. We can worship alone in the quiet with the Lord, certainly, but we must remember that we don't only have a personal identity in Christ; we have a communal one, too. Christ didn't just die for individuals. He died for the church, and He expects the church to meet regularly in His name, minister to and sharpen one another, and enjoy the strength, comfort, and growth that fellowship brings before heading back out into the world. And as a part of our gatherings, He expects the church to practice the ordinances He commanded us to enact until His return. These ordinances are the Lord's Supper and baptism, which tell His story in vivid ways and remind church members of the gospel in a communal setting (1 Cor. 11:23–26; Rom. 6:1–4: Col. 2:12). These are things He wants us to do with one another in church settings, not by ourselves. They are the ways God ordained that we might remember the story *together*.

We don't want to miss out on church gatherings and ordinances, but it takes a weekly decision. My friend Dean Inserra sends out a tweet every weekend that says, "Sunday morning church is a Saturday night decision." We may not think about

[20] Ed Stetzer, "God's Mission Has Church," Ligonier Ministries, https://www.ligonier.org/learn/articles/gods-mission-has-church.

corporate worship on the list of spiritual disciplines, but the decision to leave the comfort of our homes and go to the place where God's people are gathered is a moment of discipline. We should not forsake it, and we should look for how the Lord is glorified through it.

Worship by the Book by D. A. Carson

Worship in Spirit and Truth by John Frame

Rhythms of Grace by Mike Cosper

Sabbath

Rest is a discipline that is harder and harder to maintain in today's world. The busyness of our culture often means that even in our "down time" we are often moving at a fast pace. I regularly hear friends refer to needing a vacation after their vacation because the time away was so hectic and overwhelming that they never truly got to rest. When God created the world, He rested on the seventh day. The Israelites in the wilderness had regular rhythms that included rest, and the early church stopped what they were doing each week to meet with one another. The principle of Sabbath reminds us that we are not in control, and the world does not depend on us. It forces us to depend on our Creator and to rest in His goodness. In this media-saturated culture, it is even more important to make the decision to stop, breathe in and out, and quiet our souls. Here are some helpful resources:

24/6: A Prescription for a Healthier, Happier Life
by Matthew Sleeth
Living the Sabbath by Norman Wirzba

Putting off Anxiety and Putting on Trust

Like preaching the gospel to yourself, you may be surprised to see this listed as a spiritual discipline, but I have grown to consider it that way. Paul's letter to the Philippians says: "Don't worry about anything, but in everything, through prayer and petition with thanksgiving, present your requests to God. And the peace of God, which surpasses all understanding, will guard your hearts and minds in Christ Jesus" (Phil. 4:6–7).

It takes discipline not to worry because it is a fundamental shift in perspective. Worry and anxiety tell us that we must control our world, but God's Word tells us that He controls our world. This should bring us peace. We have to make an active daily decision that when worries come to our mind, instead of letting them simmer to a boil, we will push them out and place them before the Lord, believing that He is for our good. This is a paradigm shift for many of us, and as such, it requires discipline to turn from worry to peace. Some resources for retraining our hearts and minds are:

Calm My Anxious Heart by Linda Dillow
What Women Fear by Angie Smith
Afraid of All the Things by Scarlet Hiltibidal

In the "already-not yet" of the Christian life, discipline can feel like a challenge, especially in an undisciplined world. But we know the end of our story, the finish line of our race. Spiritual formation is an invitation to train and to cooperate with God in what He is doing in us. When we pursue these spiritual habits in full dependence on God, we are actively receiving the promise that He will make us like His Son. We are walking into our ultimate reality and becoming who He has saved us to be.

Furthermore, as we minister to other women, we should encourage them to pursue the spiritual disciplines that would be most impactful to them. We all gravitate towards some of these more so than others, but we need each of them. We might see a sister doing well in her regular reading or hearing of the Word, but have no idea about her prayer life or how well she speaks the gospel to herself regularly. These are internal and not as clearly seen. Ask her about them. And if she needs encouragement, share it with her. If she needs someone to practice these disciplines with her, walk alongside her as she grows in this area. In doing so, not only will you be getting extra practice, it will keep you both accountable and growing in these areas.

Discussion Questions

1. Why do you think the term *spiritual discipline* has a negative connotation? Does it feel negative or positive when you think about it? Why?

2. How can we move performance-based fears to habit-forming desires? How does viewing spiritual disciplines as a way to simply "remember the story" take the pressure off of your performance?

3. Which spiritual disciplines are most difficult for you? Which are easiest for you?

4. Glance through the struggles listed in this chapter. Which of these most holds you back from pursuing spiritual disciplines? What might you do to overcome this barrier?

5. Think about the women around you. Which disciplines do you notice in their lives? Alternatively, which disciplines might you encourage them to pursue as they move toward loving God more fully?

INTRODUCTION TO MIND SECTION

You keep him in perfect peace whose mind
is stayed on you, because he trusts you.
—Isaiah 26:3 (esv)

As human beings, we are thinking beings. We think on a lot of things: what we have to do each day, what we like or don't like, what we want, how we are perceived by others, problems we need to sort out, and so on. For many of us, our thoughts are driving forces behind our behavior and emotions.

Given how important our thoughts are, what does it mean to minister to a woman's mind, whether that woman is us or someone else? In this section we'll explore a woman's thought life as well as her study of God, coming to see just how weighty both these things are. If we neglect this arena, we neglect a valuable and essential part of a woman. Like the chapters before, we'll look at what the Bible has to say about these topics, some common areas of struggle, and how we can minister to one another.

8

RENEWING THE MIND

Lesley Hildreth

> Do not be conformed to this age, but be
> transformed by the renewing of your mind,
> so that you may discern what is the good,
> pleasing, and perfect will of God.
>
> —ROMANS 12:2

In the first chapter of this book, we defined a biblical woman as one who is *created by God, whose fallen nature is redeemed by Christ, and who is being restored to love God with her whole heart, soul, mind, and strength.* In this chapter we turn our attention to what it means for us to have a renewed mind. The use of the word *renewed* here assumes something about our minds, doesn't it? That something might be wrong with them? More on that soon. Suffice it to say at this point, yes, the mind needs renewal. But how? John Piper holds out a warning to us in this endeavor: "Mere intellect will not dismantle the deeply rooted errors of our

mind."[21] We cannot renew our own minds by means of our own cleverness or brainpower. Therefore, it is important for women to have a mind that is renewed by something or someone else; namely, the Lord and His gospel. In other words, we must align our minds with the "mind of Christ," to "discern what is the good, pleasing, and perfect will of God" (1 Cor. 2:16; Rom. 12:2).

This biblical renewal affects our basic thought life and our theological discernment. As believers, it is crucial that we submit our thoughts to God and ask the Holy Spirit to guide us. Our understanding of the accurate knowledge of God will lead to right thinking, which leads to obedience in Christ.

In this chapter we will discuss what the Bible teaches about how a renewed mind leads to spiritual transformation. Christians have the "mind of Christ," and this not only influences what we think, but it also changes the way we live. After considering the biblical teachings about renewing the mind, we will look at some common struggles faced by women today. In 1 Corinthians 7:31, Paul reminds us that the ways of the present world are false and fleeting. As we reject the ways of the world and embrace the truth of God's Word, our thinking begins to change over time. We will conclude the chapter by exploring the role of a renewed mind in a woman's life and what it might look like to apply these truths to this area of ministry. God has called us to make disciples (Matt. 28:18–20). This commission places us in relationships

[21] John Piper, "How Do I Take My Thoughts Captive?," Ask Pastor John, https://www.desiringgod.org/interviews/how-do-i-take-my-thoughts-captive.

with others and provides the platform through which we can help other women to renew their minds.

What Does the Bible Say about Our Minds?

As we've seen by now throughout this book, the Bible teaches that we are fallen human beings who currently live in a fallen world. We've also seen that, of many things, having a mind is part of what it means to be human—this is part of our holistic makeup. So it follows that if humans are fallen, and a mind comes with being human, our *minds* are fallen, too. These two biblical facts—that we are fallen in mind and that we live in a fallen world—make it necessary for us to renew our minds if we want to know God at all. To renew our mind means to align our thoughts with the thoughts of God.

Though it seems logically clear enough, the Bible does not leave us to deduct that our minds our fallen; it tells us so. It actually describes the fallenness of our minds in various ways. It says our minds are "hostile to God," that they are "darkened in their understanding" of His truth, and that even their attempts at thinking correctly are "worthless" or "futile" (Rom. 8:7; Eph. 4:18; Rom. 1:21; 1 Cor. 3:20). Piper was right; undoing this sad state of our mind cannot happen by sheer brainpower, for even our brainpower itself is compromised. Should we try on our own to renew our own mind, we couldn't.

Since the world, including us, is fallen, it makes sense when the Bible teaches that all have sinned (Rom. 3:23). And this sin

drives our minds toward selfishness. The only hope we have in this world is found in Christ and His gospel as the Holy Spirit changes our thinking and moves us in a new direction. All sin, as well as all obedience, begins in the heart (Luke 6:45), but is "mediated" by and "given a voice" in the mind. What do I mean? When we want something on the desire level, our mind will find a way to rationalize it or justify it or come up with some strategy to obtain it. Our mind joins our heart in its desire and paves a way for it to be satisfied. Yet that is not the only way the mind and the heart engage with each other. Conversely, the mind (our thoughts, in particular) can deeply influence the desires and motivations of our hearts. When we put our faith in Jesus, God awakens our minds to His truths, helping align our hearts to His. Therefore, our growth in Christ means we still need the Spirit to renew our minds daily.

One verse that most of us are familiar with regarding the renewing of our minds is Romans 12:2: "Do not be conformed to this age, but be transformed by the renewing of your mind, so that you may discern what is the good, pleasing, and perfect will of God." The first part of the verse tells us not to be conformed to this age. The Greek word for "conformed" is *summorphizo,* and it means "to make of like form with another person or thing, to render like."[22] In other words, when we are "conformed to this world," we think like, act like, and even desire things like those who don't know Jesus. Being conformed has a mold, and we are

[22] W. E. Vine, Merrill F. Unger, William White Jr., *Vine's Complete Expository Dictionary* (Nashville: Thomas Nelson, 1984, 1996), 121–22.

pressed into that mold so that we look like it in thought, heart, and deed. This worldliness happens naturally; it doesn't take any effort on our part. We are simply formed into the image of the world, like those who do not know or love God.

The second part of this verse instructs us to be transformed by the renewing of our mind; this takes great effort and brings great reward. The word translated "transformed" in our English Bibles comes from the word *metamorphoo* in the Greek language. This word means "to change into another form."[23] Where we were once in the world's mold or image, as Christians, we are being remolded, transformed, pressed into a different one altogether—Christ's. Paul uses this same word in 2 Corinthians 3:18 to describe the ongoing transformation in a believer's life as we grow in godliness. This Greek word also forms the root of our English word *metamorphosis*. This is the word we use when we think about a caterpillar becoming a butterfly, from a slimy worm into a beautifully colorful creature. This is God's goal for our thoughts.

Now, as we think about the Bible's instructions, I think it is also important for us to notice the verb tense Paul uses for "be transformed": first, Paul uses this verb in the present tense; it is a continuous action. Renewal of our minds is not a one-time decision. It is an ongoing and daily process. Second, the verb is also passive; God is the one who initiates the transformation process. God renews our thinking. Finally, the verb is imperative.

[23] Vine, Unger, White, *Vine's Complete Expository Dictionary*, 369.

Renewing our minds is not a request or an option; it is a command. The Spirit does the work, but we must yield to the Spirit. We have to actively choose to reject the influence of the world and to replace it with the influence of the Spirit, God's Word, prayer, and fellowship with other believers.

According to R. C. Sproul: "A renewed mind results from diligently pursuing the knowledge of God."[24] This knowledge is possible, he explains, because

> God gives us the revelation of sacred Scripture in order for us to have our minds changed so we begin to think like Jesus. Sanctification and spiritual growth are all about this. If you just have it in your mind and you don't have it in your heart, you don't have it. But you can't have it in your heart without first having it in your mind. We want to have a mind informed by the Word of God.[25]

In other words, the path to a renewed mind is through the pages of the Scriptures. God uses His Word, guided by the Holy Spirit, to break the mold of this world and transform the way we think.

[24] R. C. Sproul, "Loving God with Our Minds," Ligonier Ministries, https://www.ligonier.org/learn/articles/loving-god-our-minds.

[25] R. C. Sproul, quoted in Lee Webb, "Renewing Your Mind, Tabletalk, September 2018, accessed October 19, 2020, https://tabletalkmagazine.com /article/2018/09/renewing-your-mind.

Common Areas of Struggle

We are all born with a futile mind, unable to discern God's truth. However, as we have just read, the Holy Spirit uses the Word of God to open our eyes to His truth, transforming us by the renewing of our mind. If this is true, why do we struggle? Why is it so difficult not only to think about godly things but to use God's Word to change our thinking?

Renewing our minds is an ongoing challenge that requires discipline. Second Corinthians 3:15–18 tells us that the one and only way your mind can be renewed is by the Spirit of God working through the Word of God. Not only do these verses say that the work belongs to the Spirit, but they also tell us that the working takes place through the Word of God. The work of renewing our minds belongs to the Spirit, but we have a part to play in the process. This is where the struggle takes place.

Perhaps the main struggle most women face is a lack of biblical knowledge. If our primary source for changing our thinking is God's Word, we have to immerse ourselves in it so that it can influence us more than the world. If we don't know God's Word, we won't know what to think, and we will not have the wisdom to discern false teaching from truth. It is tempting to allow the worldly sources to shape our thinking about parenting, marriage, friendship, relationships, politics, entertainment, art, money, trials, and success, or otherwise, instead of the Word of God. But we must not let this be the case.

So, how do we overcome this struggle of lacking biblical knowledge? We can do several things to address this problem.

First, it is crucial to focus on Bible intake, getting more of the Word into our lives. We can read, meditate on, memorize, and pray God's Word. We can also use apps on our phone to listen to Scripture while we drive, exercise, or go about our daily activities. We can practice the spiritual disciplines we explored in the previous chapter. The more our minds are fixed on what God says, the better we know Him. His Word becomes the source for the renewal of our minds because we cannot align our thoughts with God's if we do not know His.

A second way of changing our thinking is to listen to gifted Bible teachers. We can listen to sermons from godly pastors, read commentaries, listen to podcasts, and read good books. We can also read Christian biographies to learn how those who went before us used Scripture to help them live.

Another area of struggle for women is our idolatry. According to Charles Spurgeon: "Whatever a man depends upon, whatever rules his mind, whatever governs his affections, whatever is the chief object of his delight, is his god."[26] My family spent nearly ten years overseas as missionaries. We were surrounded by literal, man-made idols. We worked with people who prayed to statues of the Buddha or to saints and religious relics. When someone in a more Western or secularized place like America thinks about idolatry, it is tempting to conjure these types of images. If we think of idols as relics of other religions, we miss the real danger idolatry poses to our own spiritual growth. Spurgeon is correct in

[26] Charles H. Spurgeon, *The Complete Works of C. H. Spurgeon*, vol. 47, Logos Bible Software.

his reminder that an idol is anything that commands our affection, devotion, and imagination.

What are some idols of our modern, Western culture? One of the most obvious is consumerism or materialism. These idols are revealed in our driving desire to have more, better, newer, or the latest stuff. Think for a moment how much time and energy we put into these wants. Rather than our minds being devoted to the Lord, we measure our value and worth by the latest new thing. Not only is our idolatry revealed in these pressing desires; think about how often our prayers and Bible reading get interrupted by these thoughts—or better yet, how much of our prayers actually revolve around consuming and getting more, rather than adoration, thanksgiving, and confession. It is convicting to think that sometimes our prayers reveal the state of our minds—whether they are conforming to the world or being transformed by the Spirit.

Or think about how social media fuels our idolatry of approval, reputation, or the self. Instead of asking God for wisdom through prayer or going to the Word, we search our social media accounts to see what others are saying about such things. Social media also fuels comparison; we use "friendships" and follows as measurements of our worth. We also measure the quality of our lives by what others post, which leads to envy and jealousy. This type of thinking moves us away from eternal things and encourages us to think solely on things of this world. We care more about what others think, or about how many likes we get on a post, than we do about what God thinks. The Bible speaks to every area of our

life, and it is so important for us to read and know the Word so that we can evaluate any situation or decision in light of Scripture.

A third area that many women struggle with is guilt over past sins. Our mind is a battlefield, and Satan constantly reminds us of the times we have failed the Lord. Many of us came to Christ after years of sin. The gospel teaches that Jesus died for all of our sin—past, present, and future. The Bible says in 1 John 1:9: "If we confess our sins, he is faithful and righteous to forgive us our sins and to cleanse us from all unrighteousness." However, if we hold on to the guilt brought on by past sin, we can't fully experience the power of the gospel. To have a renewed mind, we must fight the sin of unbelief and cry out to God to help us believe.

A fourth area of struggle for many women is lust. By lust we mean a thought "involving actual desire . . . to have sexual relations with someone other than one's spouse."[27] It is common to think that this is a struggle only men experience. However, we all know that women deal with lust as well. In fact, there are two ways this area of struggle can affect us. First, we can choose to feed these desires by reading, watching, or searching for material that creates illicit images or thoughts. It is important to guard our minds so that we do not feed these desires and actively take our thoughts captive to the Word of God. On the other hand, women may also be impacted by the lust-filled activities of their spouse or boyfriend. I have personally talked to women of all ages who have had to fight the thought that they aren't attractive enough or

[27] Craig L. Blomberg, *The New American Commentary: Matthew*, vol. 22 (Nashville: B&H Publishing, 1992), 109.

could never fulfill their husband's (or future husband's) unrealistic sexual fantasies because of the comparison to what he is watching online. Reliance on the Holy Spirit is key as women fight against sin and these lies.

Along these same lines, as women, we are often tempted to think on things that are untrue. For instance, we might believe harsh, untrue things that were said about us in our childhood. Perhaps they continue to take root in our thoughts. Or we might believe that we have more control in a situation than we actually do. Thus, we fail, and are failures, if we cannot work something out a particular way. These lies, ultimately fueled by sinful desires or motivations in our heart, lead to more trouble in our lives, whether that is sinful behavior or ungodly beliefs. But as Paul reminds us in Philippians 4:8: "Whatever is true, whatever is honorable, whatever is just, whatever is pure, whatever is lovely, whatever is commendable—if there is any moral excellence and if there is anything praiseworthy—dwell on these things." Not just think, but *dwell*. And do you know what satisfies all of those descriptions? God's Word. We never have to worry about the Bible containing lies; rather, we can trust that God's Word is a source of truth for our minds.

In light of all of these, we must continually preach the gospel to ourselves and think on the Word of God, for it has the power to drive out the kinds of worldly mental strongholds that have dominated our thinking for too long. We need to remind ourselves of all Christ has done for us and of God's promises. We must listen to our God's voice more than any other, and once we've listened

for that in His Word, we must speak those words of truth to ourselves daily.

Role in Woman's Life

The Bible teaches us that God's thoughts are not our thoughts and that His ways are not our ways (Isa. 55:8). God is all-knowing and we are not. His Word is given to help guide us, to be a light to our paths. Paul, in his letter to the Corinthian church, opposes their worldview and points out their false thinking and then encourages them to think rightly (2 Cor. 10:5). We must place our trust in God, and that trust should lead us to look to His Word for how to think rightly. As we see in Romans 12:1–2, when we align our thoughts with God's thoughts, we can know His will and can live a life that is pleasing to Him and that brings Him glory. That is a life not only worth living, but it is why we were created.

Renewing our minds not only helps us know and obey the will of God; it also helps us love God rightly. In her book *Women of the Word*, Jen Wilkin says:, "This explains why Romans 12:2 says we are transformed by the renewing of our minds. We come to understand who God is, and we are changed—our affections detach from lesser things and attach to him. If we want to feel a deeper love for God, we must learn to see him more clearly for who he is. If we want to feel deeply about God, we must learn to

think deeply about God."[28] As we grow in our knowledge of God through the study of His Word, we will also grow in our love for Him.

It is the same when we think about loving others. The Bible tells us that the second part of the great commandment is to love our neighbors as we love ourselves. However, our fallen minds are often consumed with selfish thoughts. Left to our own thoughts, we don't love others rightly; we love conditionally or with wrong motives. As we renew our minds with the Word of God, we are reminded of God's love for us, and this serves as a model of perfect love. The Scriptures then serve as the Spirit's tool for helping us obey both parts of the great commandment, loving God rightly and loving others as well.

Application in Ministry

In this chapter we have explored the biblical teachings around the renewal of the Christian mind. We have seen that this renewal is the key for knowing and doing the will of God, and it is also the means by which we obey the great commandment. Even though we know that having a renewed mind is important and we also recognize that God has provided His Word and His Spirit as the means for renewal, we have also seen that Christian women struggle to enjoy this reality. As a maturing Christian woman, it is not only important for you to seek a renewed mind; it is

[28] Jen Wilkin, *Women of the Word: How to Study God's Word with Both Our Hearts and Minds* (Wheaton, IL: Crossway, 2014), 33.

also important for you to guide other women in this renewal. The ministry of the church is to make disciples and equip others to do the same (Matt. 28:19–20; 2 Tim. 2:2; Eph. 4:12). Titus 2 teaches us that older women bear the spiritual responsibility for equipping younger women to walk with Jesus. As we disciple women in our churches, we need to make sure we include practical ways to instruct them in this area.

As I talk with women and answer questions about the most important elements of women's discipleship, I give one piece of advice: teach your women to saturate their lives with Scripture. This is the key to a renewed mind and, by extension, a renewed life. Apart from God's Word, our minds will always default back to idolatry and lies, which we must fight actively day in and day out.

We all know that the Bible is a big book and that there are complicated passages. However, these are usually excuses we give for not reading the Bible. In fact, it is my experience that most of the complexities women fear evaporate when we just start reading.

So, how do we saturate ourselves with Scripture?

1. *Read, reread, and then reread the Scripture.* Find a reading plan, a Bible translation, an app, or anything else that encourages reading. Encourage women to make their Bibles a well-used book.

2. *Mediate on the Word.* Teach women to choose passages of Scripture and think deeply about them. Turn the passages into prayers, journal entries, and even conversation points.

3. *Memorize the Word.* The Spirit uses the Word of God that is implanted in our hearts to renew our minds. Psalm 119 tells us

that if we hide God's Word in our hearts, we will not sin against Him. Help your women memorize chunks of Scripture that help them fight against sin and remember the gospel.

4. *Prioritize the Word.* It is also important that we remind the women in our ministries to make sure they invest more effort in these three things than they are in seeking out other sources of information. Social media, television, music, and books are not necessarily evil, but they can be a distraction from the Word of God.

The pathway to a renewed mind is not complicated. In fact, it is simple. The Spirit of God uses the Word of God to shape the thinking of the child of God. Our responsibility is to immerse ourselves in the Word and then enjoy all God does in our lives.

Discussion Questions

1. What thoughts are you telling yourself regularly? Make a list; write them down. Then compare them to what Scripture says about those topics or issues.

2. Write down the Scripture passages you compared to your thoughts and meditate on them. Then make a plan to memorize them.

3. What do you tend to dwell on the most (what consumes your daily thoughts)? Why do you think you are mentally consumed by this? What do you think you will gain by dwelling on it so often?

4. What are your biggest fears about approaching Scripture? Who is a more mature believer in your life that could help you overcome these fears and commit to knowing God's Word?

5. In this chapter we discussed some common areas of struggle in renewing our minds. Identify which area is most difficult for you. Take one action step this week to grow in this area and share with a close friend for accountability.

9

THEOLOGICAL STUDY

Christy Thornton

You are being renewed in knowledge
according to the image of your Creator.

—COLOSSIANS 3:10

Introduction

I've spent a lot of time talking about theology with women. In my context I've noticed that it's pretty common for women to have a negative disposition toward it. I once had a woman tell me, "I just wish we could stop with this theology stuff and get on with the real work of the church!" She put it bluntly, but I think she expressed a sentiment shared by a number of women. To be fair, she's got a point.

If theology is merely a theoretical discussion in some ivory tower about who God is and what He is doing in the world with

no interaction with the lives of real people, she's absolutely right. One gift we offer the church is focused attention on the practical needs and opportunities of ministry. Indeed, we should stop Christian dialogue that solely hems and haws about impractical ideas and return to giving our lives to the work of ministry and fulfilling the mission of the church.

Here's the thing: theology, approached rightly, certainly involves mental reflection on who God is and what He is doing in the world. But that reflection doesn't exist in a vacuum, hang in midair, or live in an ivory tower. It emerges from somewhere—namely, our Christian experience as we seek to live lives conformed to God's Word. And it is motivated by something— that is, our devoted desire to know God and participate in His mission. In these ways, "this theology stuff" is not divorced from the lives, desires, and experiences of real people; it is irrevocably tied to them. Any model for theological reflection that does not drive us to love God and love our neighbor is theology severed from its biblical anchor and purpose. Theology, while engaging the mind, is always undertaken by the whole person for faithful living.

A Definition of Theology

So, what is theology exactly? Countless theologians have offered definitions of theology. For our purposes, while many might expect to see theology defined as something akin to "the study of God" or "what a person believes about God," we will

instead define it as *knowing God and being formed into the image of Christ.* Now you may be thinking: *Wait, doesn't being "formed into the image of God" basically just mean sanctification? Why are you defining something as big as theology that way?* The reason for defining theology this way is because the Bible does not paint theological knowledge as an academic study or a set of correct beliefs or thoughts, but more so a dynamic growth experience of both *knowing* (God) and *changing* (into the image of Christ). While many other definitions of theology are certainly helpful, at the end of the day, we want to talk about theological knowledge in a way that is biblically shaped. Take Paul, for example, when he talks about knowing Christ in Philippians 3:7–10. He is not primarily concerned with thinking the right thoughts about Christ, but how knowing Christ changed him in salvation and how he is being formed as he grows in knowledge of Christ. We could also look at verses like Jeremiah 31:34; John 17; Col. 3:8–17; 1 John 4:7–8, and Ephesians 4:13, among others. As we gain a better understanding of how the Bible talks about knowing God through passages like these, we will find that being formed into the image of Christ is at the center of theology.

In this chapter we're going to take a further look at the nature of theology and how it relates to our lives as women. While theology is itself a holistic category, we'll focus more directly on how we can love God with our whole mind through theological reflection.

Biblical Teaching on Theology

If theology is knowing God and being formed into the image of Christ, we need to consider a few basic questions. First, who is God? Second, how can we know Him? Obviously, answering these questions is no small undertaking. In such a brief space, there's no way to give a complete treatment of the Bible's testimony to knowing God. Instead, we'll zero in on a few sets of verses in John 14–17, Jesus' teaching to the disciples prior to His crucifixion. I encourage you to open your Bible and walk through the passage with me. In this section my aim is to demonstrate how we know God and the results of knowing God.

As we look through these verses, we'll see first how Jesus teaches that God—Father, Son, and Holy Spirit—is one. By virtue of God's oneness, He knows Himself completely, and through the life, death, and resurrection of Jesus Christ, He has made Himself known to us.

Right at the beginning of the passage, Philip asks Jesus to "show [them] the Father" (14:8). To answer Philip's request, Jesus responds by giving us a sneak peek into God's internal, eternal life. He says, "Have I been among you all this time and you do not know me, Philip? The one who has seen me has seen the Father. How can you say, 'Show us the Father'? Don't you believe that I am in the Father and the Father is in me?" (vv. 9–10) Jesus begins by talking about the Son's eternal relationship to the Father, and in the next breath He begins to speak of the Holy Spirit's participation in the Godhead (vv. 15–20).

These verses offer us a treasure trove of ways to answer our questions. First, to when it comes to our question of who God is, Jesus answers: God is Father, Son, and Holy Spirit. (Now some of you may realize we're going to have to talk about the Trinity if we're going to answer the question of who God is. Already you may feel your anxiety rising because the Trinity feels like theology for the A-team, professional theologians. Don't freak out. The truth is, the Trinity sits at the center of knowing God for any person, whether they be an ordinary Christian in the pew or a preacher in a pulpit or a scholar in a study room. No need for anxiety. We're literally just talking about the same God you already know and love.)

How is Jesus saying this, exactly? Let's think about it. In this passage Philip asks God the Son directly about His relationship to God the Father. Why? Because Philip desires to see God, whom he seems to assume is the Father but separate from the Son. Said another way, Philip's question is telling; he is asking Jesus to reveal the Father because he assumes the Father hasn't already been revealed. Philip thinks the Father is a separate entity altogether, an entity that Jesus can bring out of the shadows and into the light, due to His special relationship with Him. Like a newcomer trying to make social connections in a ballroom full of important people—or better yet, a newcomer strategizing a way to be introduced to the prominent host of the party who has been mysteriously elusive all evening—Philip sees Jesus as the relational connection he needs to be introduced to the Father. Probably to Philip's surprise, Jesus answers that there is no God lurking in the

background for Him to reveal. Rather, Jesus and God the Father are one, to the point that to see God the Son means you have seen God the Father.

How can that work, though? How can it be possible that seeing the Son means seeing the Father? Jesus says this is possible because the Father indwells the Son, and the Son indwells the Father. Then in verses 15–20, when He brings the Holy Spirit into the conversation, He shows that the Holy Spirit shares in the mutual indwelling of the Father and Son. At this point we can see there's a sameness in God's triunity—a "oneness" in His "threeness," as it were. The Father, Son, and Holy Spirit, while distinct, share a unity in the way they eternally indwell one another.[29] Through His mutual indwelling, God's eternal being is full and active, brimming over with love and life. He is not static, boring, or lonely. He is love, and He is life.

We've answered the question of who God is—God is Father, Son, and Holy Spirit. Let's now turn our attention to the second question: How can we know God? Put simply, we know God in Christ. In John 17, Jesus prays to the Father in front of the disciples. At the end of His prayer, Jesus says, "Righteous Father, the world has not known you. However, I have known you, and they

[29] You may still be wondering: *But what does it really mean that Jesus is in the Father?* Great question. Here's the rub: we're humans with little human brains talking about an infinite God. At the end of the day, when we ask: "How does the mutual indwelling of the Father, Son, and Spirit really work?" we have to answer: "I don't know. It just does." There are things we can definitely know and say about God's trinity, but ultimately the detailed mechanics of how it works remain wonderfully mysterious.

have known that you sent me. I made your name known to them and will continue to make it known, so that the love you have loved me with may be in them and I may be in them" (17:25–26).

Jesus starts with two parallel realities: the world does not know the Father, but Jesus does know the Father. Here we encounter a key idea for defining theology: in an eternal, complete sense, only God truly and fully knows God. Knowing God begins internally to God. Just as His being is shared, His self-knowledge is shared knowledge in the Father, Son, and Holy Spirit. Because the Father, Son, and Holy Spirit indwell one another and share the same being, they know one another completely.

This lands us in a bit of a quandary. If only God knows God, and we are not God, how can we know God? God's self-knowledge is an unbroken circle, a closed circuit. Even if we try our hardest, we cannot break into it on our own. God has to choose to act outside of Himself to make Himself known to us. In other words, if we are to access the shared knowledge of God that the Trinity alone enjoys, God has to bring us into it. Knowing God is not possible any other way; our only hope is if God decides to reveal Himself to us.

Good news, though. He has! On top of giving us Scripture, God has revealed Himself to us by sending His Son. Jesus resolves the tension between our inability to know God and His self-knowledge of God *with Himself*. He says, "I made your name known to them" (17:26). He is echoing His answer to Philip and reiterating a consistent theme in John's Gospel. Jesus has come to make God known. Back in John 1, John concludes his

introduction like this, "No one has ever seen God. The one and only Son, who is himself God and is at the Father's side—he has revealed him" (John 1:18). This declaration is the driving theme in the Gospel of John: through the incarnation of the Son of God, God has made Himself known to us. In fact, Jesus teaches that this reality is the driving theme of the whole Bible (Luke 24:27).

So, how do we know God? In Christ by the power of the Holy Spirit. Knowing God in Christ is more than just our mental assent or being able to say the right things about Jesus. Jesus ends His prayer in John 17 by saying He will continue to make God known "that the love you have loved me with may be in them and I may be in them" (v. 26). The way Jesus makes God known, ultimately, is through living in us, and He does this by the power of the Holy Spirit.

Jesus foretells the indwelling of the Holy Spirit back in John 14 when He promises to send the Holy Spirit so that He would be in the disciples (v. 17). When we are saved by grace through faith, the Holy Spirit dwells in us, and since He also indwells the Son, He unites us to Him. This is the crazy part—through union with Christ, we are welcomed into the mutual indwelling of God's eternal life. We have life in God's own life and know Him in His own self-knowledge. This is what Jesus means at the beginning of His prayer when he says, "This is eternal life: that they may know you, the only true God, and the one you have sent" (John 17:3). Knowing God is having life in Christ by the power of the Holy Spirit.

As Christians, we spend our lives, and apply our minds to reflect on this reality that God loved us so much that He became human to live the life we could never live, to die the death we deserved, and to rise again on the third day that we might have life in Him—that we, the rebellious outsiders, might be welcomed into the internal, eternal love of God.

The Role of Theology in a Woman's Life

As a part of our union with Christ in the Spirit, we share in the mind of Christ. In Christ, Christians are made new, and a part of this newness is a renewal of our minds. Before we are made new, our minds are turned in on themselves and incapable of knowing God (Rom. 1:28; 8:7). In Christ, our minds are renewed and are being renewed. As a statement of our salvation in Christ, our minds are definitively made new in Him. Even so, we are still in process. We still "know in part," and await the time when we will "know fully, as I am fully known" (1 Cor. 13:12). In the meantime we are being formed into the image of the Son (Rom. 8:29). That's why Paul exhorts us to be transformed by the renewal of our minds (Rom. 12:2).

That's what we are doing in theological reflection. We, who have the mind of Christ, use our minds to worship Him by reflecting on who God is and what He has done, made known in the Bible. As we dwell on Him, respond to Him in obedience, and tell others about Him, we are being formed into His image. When we use our minds to do theology, we are worshipping God

with our minds and becoming like Christ in our lives as a result of knowing Him.

Theological reflection allows us to use our renewed minds, steeped in the Scriptures, to rightly articulate our faith to one another and to the lost. The term *reflection* here is key. Sometimes there's a temptation to make theology a rote articulation of doctrinal truth. That's not a bad thing in itself. In fact, for centuries the church has taught something called "catechisms," which is literally the repetitive memorization of doctrine. This type of memorization is certainly helpful (that's why children's programs around Scripture memory are so popular!). But, for well-rounded theology, the goal isn't simply theological regurgitation but the intentional development of biblical and theological instincts. As we think on the Scriptures in the Spirit and we are transformed by the renewing of our minds, we develop righteous "knee-jerk" reactions. Being godly and living righteously become natural because we are living out of our human nature made new in Christ. After our salvation in Christ, the ongoing activity of theology forms us to be like Christ in the whole of our lives.

The role of theology in a woman's life surfaces in basic Christian practices. Any faithful Christian will likely spend time reading the Scriptures, praying, worshipping with the church, and sharing the gospel. All of these activities are inherently theological. They involve us using our reconciled minds to think in Christ, with other Christians, and through our proclamation of the gospel to make Him known in the world.

Common Struggles

There are parallel struggles when it comes to loving God with our minds in theological reflection. On the one hand, we might be tempted to overvalue the work of our minds. This temptation leads us toward rationalism, a theory that sees reason (rather than experience) as the authoritative path to certainty on any matter. On the other hand, we might be tempted to undervalue the role of our minds in the Christian life. This leads toward anti-intellectualism, which sees emotions, experience, and actions as the path toward certainty, treating things like reason or education or expertise as suspicious or even dangerous. One sees reason as ultimate, and the other sees it as totally untrustworthy. Both of these temptations are commonplace in the church, but one may have greater influence in your context than the other.

When we give in to the temptation of rationalism, we value the work of the mind over other aspects of our humanity. Sometimes people with this perspective treat one another as if they are brains on a stick. The goal of theology becomes having the right answers. When success becomes knowing, knowledge becomes power, and people get puffed up. When people are puffed up because they are winning the theological game, it becomes easy for them to do harm with their knowledge. Suddenly theology becomes combat. They spar with one another, aiming at the brain, but often miss hitting the heart instead. They do relational damage, hurting their witness for Christ in the world.

Making too much of the mind, though common, is a distortion of a biblically informed view of theology. Knowledge that

puffs up goes against true theological knowledge (1 Cor. 8:1). As I noted above, knowing God leads us to be formed into the image of Christ. Christ, who had all knowledge, humbled Himself by taking the form of a servant (Phil. 2:7). Now, as we become like Christ, our theological knowledge drives us to service—to serve the church and participate in God's mission in the world.

Of course, that's not to say that having proper doctrine, and knowing the right answers, is unimportant. In fact, it's very important. To think otherwise is to give in to the opposite temptation and not make enough of the mind. People with this perspective are quickly dismissive of theological reflection. They think it's a waste of time, they think it's impractical, or they assume they are more of a "feeler" than a thinker and would rather approach life with their heart as their guide. Rather than a brain on a stick with no heart, they are a heart on a stick with no brain, elevating their feelings as ultimate. Giving into this temptation is dangerous because those who do run the risk of not only being jerked around by their unchecked hearts into wrong places but, worse, losing the centrality of Christ and His gospel in their ministry. Every facet of Christian ministry requires some type of thinking about who God is and what He has done in Christ. If we don't take time to listen to God in the Scriptures and think about what He has done in Christ, we run the risk of losing sight of the gospel. As we considered earlier, Jesus is Himself the heart of the Scriptures and the gospel. If we want to know Him and make Him known in the world, we have to use our minds and think well about who He is and what He has done. All aspects of the Christian life require

theological reflection. Theology is always more than an activity of the mind, but it is never less than an activity of the mind.

There is a third temptation, one less often spoken aloud: the temptation to believe you are not capable of theological reflection. Instead of picking theological fights or avoiding them in favor of practical ministry, these people often cower in the back, sheepishly unsure that theology is for them. If this is your experience, hear some good news: in Christ, theological reflection is for all Christians, not on the basis of our own intellect but on the basis of the mind of Christ in which we share by the power of the Spirit! We all, every one of us, should fight not to give into this temptation, for it puts more trust into ourselves than we put in Christ. The extent to which we can trust God to save us from our sins is the extent to which can trust Him to help us grow in knowing Him and making Him known. As we reflect on who He is and what He has done in faith, God will always show Himself faithful in Christ.

Application to Ministry

As we shared above, using our minds in theological reflection sits at the heart of our ministry in the church. One way we become like Christ is by leading others to use their minds in Christ. We do that both in the church and in the world.

In the church, as we do ministry, we should challenge Christians to use their minds to love God and to trust Him with the whole of our lives. We can do this in all sorts of ways. Primarily,

we do this by centering our ministries on the Scriptures. The Bible is all about Jesus. Knowing Jesus means knowing the Bible.

As we teach and preach the Scriptures, we invite women to think along with us. One wonderfully fruitful way to challenge them to reflect on who God is and what He has done in Christ is asking questions. These questions should arise from the Bible passage we are studying, as well as the context of the hearer. Sometimes questions from the passage are written in the text itself (i.e., "Who do you say that I am?" in Matthew. 16:15). Other times we naturally form questions around the things that puzzle us in a passage. (In John 10:38, what does Jesus mean when He says, "I am in the Father"?) In either case, part of using our minds to love God means acknowledging that there are things we don't know, things that puzzle us. Our knowledge is a partial knowledge, a growing knowledge. Being comfortable asking questions from the text of Scripture and leading others to use their minds to think through answers is one way our knowledge of God grows. We've already started doing this by asking, Who is God? Other central theological questions are: Who is Christ? What does it mean to be saved? What/who is the church? What happens at the end of the world?[30]

Not only do we ask questions from the text, but we also ask questions from the context. In every Bible study, participants walk

[30] Theologians often refer to these questions by their doctrinal titles. "Who is Christ?" might be referred to as Christology. "What is the church?" is the doctrine of the church or ecclesiology. "What will happen at the end of the world?" is the doctrine of last things or eschatology.

through the door with questions. Sometimes those questions come from the culture around them. (What does the Bible really teach about gender? Can faith and science coexist?) Sometimes those questions come from life experiences. (How can God be good when I'm in so much pain?) In both cases we facilitate people asking their own questions. Then together, using our minds in Christ, steeped in the Scriptures, under the guidance of the Holy Spirit, we begin to formulate answers and responses. Christ is present and the Bible is relevant in the context of our lives. To help women love God with their minds means creating a space to ask the hard questions. Then, as we consider the answers, we grow in faith, surrendering our lives to Him that He might form us to be more like Him.

Yes, Bible study is one way we can use our minds in ministry. But that's not the only way. Another eternally significant endeavor that requires our mental energy is participating in God's mission with other women and encouraging them to participate in His mission as well. In a variety of ways, we use our minds to help make Him known in the world. For example, as we share the gospel with our friends and neighbors, we think well about the questions they may have, just as we do in the church. Yes, anticipating these questions takes time and thought, but when we offer our minds and our minutes to the task, we can help them see how those questions are answered in Christ and written in the Bible that they, too, might respond to the gospel with faith and repentance.

As a final note, we must undertake every bit of this ministry in Christ relying on the power of the Holy Spirit in us, and remind our sisters to do the same. We trust that we are made new

in Christ, and we pray for Him to use us to make Himself known as we lead others to use their minds in theological reflection. So whether we are exploring what it means to obey rightly, how we have union with Christ, or the role of the Spirit in the life of the believer, we do all of those things under the lordship of Christ and by the power of the Spirit. We live theology by knowing and relating to God.

Discussion Questions

1. Before reading this chapter, when you thought of theology, what came to mind? Is thinking of theology as "knowing God and being formed to His image" a new idea for you?

2. Have you ever considered the significance of God making Himself known to us in Christ? In your own words, why does this matter in your life?

3. In this chapter we mentioned that you participate in Christ's own mind when you think theologically. How does this truth change your approach to theological reflection?

4. When it comes to the way you view your mind, which temptation do you struggle with most? Are you more likely to overemphasize your mind, underemphasize your mind, or believe you are incapable of using your mind to think theologically? Why?

5. How can you lead others to use their minds to love God?

INTRODUCTION TO STRENGTH SECTION

Finally, be strengthened by the Lord
and by his vast strength.

—EPHESIANS 6:10

Up until this point we've explored how we can minister to a woman in the realms of her heart (emotions and desires), soul (spiritual life), and mind (study of God's Word). This section aims to explore a woman's strength—in particular, her physical body and the relationships she has with others. Both a woman's body and her community, namely the church body, are essential parts of a woman's life, but often are areas that are either ignored or cared for on autopilot. And yet both are gracious gifts from the Lord that are to be stewarded for His glory. As with the sections before, we'll review what the Bible has to say about each of these topics, some common areas of struggle, and finish with ways we can minister to women's strength.

10

PHYSICAL BODY

Kristin L. Kellen

Don't you know that your body is a temple of the
Holy Spirit who is in you, whom you have from
God? You are not your own, for you were bought
at a price. So glorify God with your body.

—1 CORINTHIANS 6:19–20

Introduction

What comes to mind when you think about caring for your
body? For some of us, the memories of New Year's resolutions or
failed gym memberships replay in our heads. We wish we thought
more about our body and the care it deserves, but other things
feel more important. We undervalue our body, if we're honest. For
others of us, this question likewise makes us squirm—though not
for undervaluing our bodies but for overvaluing them. Perhaps we

are obsessed with counting every calorie we eat, unable to sleep if we haven't hit the gym that day, or spend an irresponsible amount of time and money on our physical appearance. Now, what if I asked you to think about caring for another person's body? That one gets a little trickier.

When considering ministry to women that is holistic in nature, we cannot neglect the reality that we have bodies. We are physical beings by our very design. But for those of us who undervalue our bodies, oftentimes our approach to caring for ourselves physically is simply to avoid being sick (who has time for that?) or to attend the occasional exercise session. Maybe throw in some healthy eating now and then, and we're fine, right? For those who overvalue the body, the approach and assumption can seem equally harmless—being meticulous about our physical health and appearance is good, right? The body's a temple!

This chapter seeks to challenge some of these thoughts. Specifically, this chapter aims to demonstrate the necessity of ministering to women as physical beings, and not just when they're ill. We'll see that the Bible speaks often about the role of the body in our walk with the Lord, identify some common areas of struggle, then give some application for ministry.

What Does the Bible Say about Our Bodies?

None of us can deny that we have a physical body. We are physical beings with an "outer self," and yet as we've discussed earlier in this book, we also have an inner self. God created us to

be embodied souls; to separate body and soul is unnatural and only happens temporarily at death before the resurrection. We will spend eternity with a physical (and perfectly restored) body.

From the very beginning, we were created with a physical body. In the first chapter of Genesis, God created man by forming him from the dust of the ground and breathing (or "spiriting") life into him. God then takes a physical part of man and creates a companion, woman. They are then given the mandate to go forward and multiply (Gen. 1:28); in their unity they are to make other soul-embodied people.

From that beginning point up until right now, every human in history has been created with both a spiritual and a physical nature. Each and every person is unique, including their physical appearance. Even identical twins have slight differences between them. Some people are tall, others are short. Body types and fingerprints are different. Each person has a slightly different skin color, hair color, and eye color. No two people are exactly alike; this was intentional by our God. Imagine people as a mosaic: despite unique differences in individuals, the collection of image bearers taken together reflect our Creator in fuller and more beautiful ways. Each person is fearfully and wonderfully made, known perfectly and intimately by their Maker (Ps. 139).

And yet each person on this planet has several things in common, one of which is our physical natures. We all have brains and hearts and lungs. We all eat and sleep; we all move and think. Though God created male and female as distinct from each other, we still have more in common with the opposite sex than we have

differences. Our bodies mirror each other and our Creator. Jesus stepped down into creation and took on a physical body like ours.

The Scriptures are clear on the purpose of the body, particularly a Christian's body. Paul reminds us in 1 Corinthians 6:19 that our bodies are a temple of the Holy Spirit, whom we have from God. He says earlier in chapter 3 that the body as the temple is sacred. Here, Paul is drawing a clear parallel between our bodies and the literal, physical temple of the Old Testament where God dwelt with His people. God houses himself in our bodies. Given this remarkable truth, it makes perfect sense that Paul's deepest heart cry is for Christ to be "highly honored in my body" (Phil. 1:20) in every way imaginable—a banner statement we all should declare along with him.

Furthermore, Paul teaches in Romans 12:1: "Therefore, brothers and sisters, in view of the mercies of God, I urge you to present your bodies as a living sacrifice, holy and pleasing to God; this is your true worship." Our bodies are to be a "living sacrifice," used for God and His glory. That means in everything we do, as embodied beings, we are to live in such a way that is worshipful. We eat and drink to the glory of God, we serve others with our hands to the glory of God, and we work to the glory of God. Our bodies are an active part of each of these.

Our bodies were also designed with basic needs that have to be met. We require food, water, and shelter to continue living. Our bodies need fuel and rest to work properly. This design was created before sin entered the world, and the needs associated with it are good and proper for us.

Yet our bodies are also broken. It doesn't take much thought to identify ways in which our bodies fail. People get sick. Our bodies fail to function the way they were intended to function. And ultimately, we die. All of these are the result of sin, whether that be in the general, worldwide sense (flowing from the effects of the fall) or the specific, personal sense (flowing from volitional, sinful choices).

But praise be to God that it doesn't end there. One day our bodies will be restored, perfectly and fully. As Paul writes in Philippians 3:21: "He will transform the body of our humble condition into the likeness of his glorious body, by the power that enables him to subject everything to himself." Hear this, sister: one day our bodies will be like Jesus, glorious and complete. Part of the reason we should value our body is because it really will live forever (in a glorified state). A physical body was God's design from the beginning and will remain His design in the end. Sin and death take their toll, but it can't thwart God's intent. In other words, the body is not seen as a "throwaway" to God. He will resurrect it and restore it and fix everything that went wrong with it and then glorify it! If God is *this* committed to our bodies, shouldn't we be?

The Role of the Body in a Woman's Life

Now that we've established that we are physical persons and that the Bible has much to say about our bodies, this section will give greater clarity about how that plays out in everyday life. In

other words, what is the role of our bodies as it relates to life, relationships, and needs?

Quite often this question seems most pertinent when our bodies aren't working properly. We generally care for our bodies on autopilot; I eat when I am hungry, and I sleep when I am tired. I use my hands and feet without thinking much about it. My body works in tandem with my mind to speak, drive, eat, and do all sorts of other normal, everyday activities.

And yet sometimes my physical needs or means of expression become much more difficult when something goes wrong. When I am sick, it's harder to think clearly or to function normally. When I get a cut on my finger, it's harder to do normal tasks like cooking or writing. My body has a tremendous impact on everyday living, especially when it doesn't work right.

Two implications flow out of this consistent, inescapable influence of our bodies. First, I must remain aware of and attend to the needs of my body. If I need fuel, I must eat. If I need rest, I must rest. And if I have an injury, or something that isn't working properly, I must attend to it.

The second implication may not be as clear: I must be aware of my physical body's role in spiritual matters and deal with it properly. The Scriptures remind us that the body gives expression to sinful desires in our hearts. Jesus gives us a helpful teaching in this area in the Sermon on the Mount:

> You have heard that it was said, Do not commit
> adultery. But I tell you, everyone who looks at a
> woman lustfully has already committed adultery

with her in his heart. If your right eye causes you
to sin, gouge it out and throw it away. For it is
better that you lose one of the parts of your body
than for your whole body to be thrown into hell.
And if your right hand causes you to sin, cut it
off and throw it away. For it is better that you
lose one of the parts of your body than for your
whole body to go into hell. (Matt. 5:27–30)

In this passage Jesus makes it clear that the body may be a
participant in sin. And His solution is radical: cut it off. While
most commentators would agree that Jesus isn't advocating a lit-
eral amputation of one's hand or gouging out of one's eye, His
point is clear: we should take sin seriously. Though sin ultimately
originates in the heart, it is played out and expressed through one's
body. Said another way, when we experience desire on the inside,
we then use our body to achieve that desire on the outside. Our
body serves our heart and lives out its wishes. It's the instrument
by which we get what we want. So, when someone does something
wrong with a physical body part—for example, their physical eye
moves so they can look upon another person lustfully—it's clear
to Jesus that the eye didn't act on its own. The heart ultimately
guided the eye to move, and therefore *both* are guilty of sin. This is
why "the whole body" suffers the consequences for sin. For Jesus,
the body tells on the heart. And of course, He's right.

But just as the body can be used as an instrument of sin, it can
also be used as an instrument of worship and service. The Psalms
speak often about lifting hands in worship, singing, shouting for

joy, or playing musical instruments (Pss. 63; 71; 100; and others). In the New Testament, Paul warns believers: "And do not offer any parts of [your body] to sin as weapons for unrighteousness. But as those who are alive from the dead, offer yourselves to God, and all the parts of yourselves to God as weapons for righteousness" (Rom. 6:13). We are to use our bodies for the worship of God, not for the worship of self. And that worship involves the whole person, body and soul.

Common Areas of Struggle

If we're honest, all of us struggle in some area in caring for our bodies. This becomes especially true as we add more and more responsibility to our lives. And for most of us, the areas of struggle probably relate to our basic needs: sleep, food, and healthy maintenance habits. Because they are our basic needs, oftentimes we forget to pay attention to them. Our bodies are incredibly resilient, but they are still broken.

Taking these one by one, oftentimes sleep is something that gets pushed by the wayside. Any parent knows this to be true, though I'd venture to say that everyone can relate with this struggle at some point in their lives. We take for granted that God designed rest as *good*. God Himself rested. Interestingly, a lack of sleep has been linked to a myriad of other struggles in life: trouble concentrating (impairing judgment), lowered immunity (increasing sickness), mood changes, weight gain, and overall lower life

expectancy. Sleep is vital to our overall well-being and for proper functioning.

Similarly, we may struggle with disordered eating. Just like sleep, God designed food to be *good*, but the misuse or abuse of food is not. And this isn't just when disordered eating becomes an eating disorder (there's a difference). Food may be misused either in eating too much, eating too little, or eating for the wrong purposes. Food was primarily designed by God to provide fuel and energy for the body and secondarily for taste and enjoyment; it was not designed the other way around. It was also not designed to take the place of God when it comes to the common human pursuit of comfort or refuge. Food shouldn't be the place we run for comfort if we are upset or a place of escape when we know God is the only one strong enough to be our refuge.

Alongside sleep and food, many of us struggle with regular body "maintenance." This may be in the form of neglecting to exercise, avoiding going to the doctor when we need to, or even taking restful breaks to rejuvenate. Oftentimes the busyness of life becomes a distraction from these things, or we simply feel we don't have the time to do what we need to do to care for ourselves.

Lastly, many people struggle with physical ailments or disabilities. Because of the fall, our bodies may not work properly or something has been broken. These physical maladies bring with them all sorts of struggles: caring for oneself, providing for oneself, or even emotional expression or regulation. These physical struggles often lead to feelings of isolation or shame, furthering the struggle to ask for help.

Hopefully in reading this section so far, you're able to identify areas that could use some work. In doing so, be reminded that others in your life likely struggle with some of the same things. You are not alone. A focus on our own struggles, then, shouldn't just be about areas we need to improve but should spur us toward caring for others in similar ways.

Ultimately, the good news in all these struggles is this: God is faithful to help us in a myriad of ways. One, through the power of His Spirit, He can help us have healthy convictions and boundaries around our physical habits. With this empowerment, we really can change. Two, He has given the world doctors as a gift to help humanity thrive, and we can access those doctors for help should we need it. Three, the Lord has given us His Word and His church—two places we can run for the comfort, rest, and accountability we need to take care of the bodies He has given us. And four, no matter how hard or dark the physical struggle, we all have the hope of the resurrection in front of us. It's the ending to all of our stories, where brokenness will be no more and the body will be restored, renewed, and glorified.

Application to Ministry

What do we take away from this discussion? We have physical bodies, and those around us are embodied, but what does this really mean for the way we minister to ourselves and others in everyday life?

First, it is good, not selfish, to care of our own bodies. Using the overarching theme of this text, we are to love God with all of our heart, soul, mind, *and* strength; that means we are to love Him with every part of who we are. We are stewards of our bodies and bear His image, so taking care of His temple is an act of obedience and service to the Lord.

An important reminder here comes from the ministry of Jesus. He demonstrated often that both spiritual and physical needs needed to be met. The gospel is of supreme importance, but how often do we see Jesus feeding people, healing their physical ailments, or meeting physical needs before He tells the people about Himself? So often! He understood, as the embodied, incarnate God Himself, that the body matters.

Second, we must view our bodies rightly, particularly in view of how Scripture speaks (noted above). We must continue to view our bodies, and the bodies of others, as God-given instruments of worship and service, whose proper orientation should be toward God and not ourselves. This means we should seek to treat our bodies in ways that care well for ourselves and others. More specifically, it means attending to needs like eating, sleeping, exercising, and resting. It also means being aware of potential struggles and actively seeking to combat those struggles. When we don't do this, we not only compromise our own health, but we also compromise our ability to minister to others effectively.

Third, just as Paul reminds his readers in Romans 12:1: "Present your bodies as a living sacrifice, holy and pleasing to God; this is your true worship," we are to do the same. Our bodies

are active participants in ascribing honor and glory to God. They are either used to worship Him or serve ourselves. We are to sacrificially use our bodies for His glory rather than our own. What does that look like? It looks like the obvious sorts of things we might naturally assume already—say, not using our body to harm another person. But it also means things that seem less obvious, for example, the subtle ways we present our bodies on social media, or the sarcastic and shaming face we make when our friend or spouse says something we disagree with. It's helpful to remember Jesus' principle here: the body tells on the heart. No matter the action, the big questions we must answer are these: *In this instance, is the way I'm using my body an effort to gain glory for God or myself? Am I using my body as an instrument for good or for evil right now? What does my body say about my heart in this moment?*

Finally, it is our responsibility as believers to care for others within the church. It is fitting that Paul uses the analogy of the human body in 1 Corinthians 12:14–26 when he writes:

> Indeed, the body is not one part but many. If the foot should say, "Because I'm not a hand, I don't belong to the body," it is not for that reason any less a part of the body. And if the ear should say, "Because I'm not an eye, I don't belong to the body," it is not for that reason any less a part of the body. If the whole body were an eye, where would the hearing be? If the whole body were an ear, where would the sense of smell be? But as it is, God has arranged each one of the parts in the

body just as he wanted. And if they were all the same part, where would the body be? As it is, there are many parts, but one body. The eye cannot say to the hand, "I don't need you!" Or again, the head can't say to the feet, "I don't need you!" On the contrary, those parts of the body that are weaker are indispensable. And those parts of the body that we consider less honorable, we clothe these with greater honor, and our unrespectable parts are treated with greater respect, which our respectable parts do not need.

Instead, God has put the body together, giving greater honor to the less honorable, so that there would be no division in the body, but that the members would have the same concern for each other. So if one member suffers, all the members suffer with it; if one member is honored, all the members rejoice with it.

Though Paul is talking about spiritual gifts here, comparing some to the foot, some to the hand, and some to the eye, he gives us a pertinent reminder that God arranged the body (both physical and metaphorical) as He saw fit. And He did so "that the members would have the same concern for each other" (v. 25). Did you catch that? God equipped us as parts of the larger body to care for the individual needs of one another, physical needs included. How does this look, you may ask? It depends on your context. For some, it may look like making a meal for a sick family

or a new mother. For others, it may look like hitting the gym with a friend who is scared to go alone and wants accountability. For still others, it might mean driving an elderly church member to her doctor's appointment. In any case, the question to ask here is this: *Who around me needs help caring for her physical needs right now, and how has God positioned me to help?*

Conclusion

The body is a significant part of who we are; we cannot escape it. Although it was created in service to both God and others, our bodies also have needs that must be met. Those needs may be simple, like providing a meal or taking care of someone when she is sick. Or those needs may be more complex, like ongoing care in the midst of a terminal illness or failing mind. But within the church, God has equipped us for ministering to women holistically, including their physical bodies.

Let us see this attention to our physical beings as part of our whole worship of our Creator, the Giver of our bodies and souls. Let us use our bodies as participants in loving the Lord and loving our neighbor as ourselves (Matt. 22:37–40).

Discussion Questions

1. How have you either neglected or glorified your body? What impact has that had on your everyday life?

2. In this chapter we discussed that many of us can use our bodies as instruments for self-glory or ungodly purposes in subtle ways without realizing it. Is this true for you too? How so?

3. Share two or three unique ways you intentionally care for your own body (eating healthy, regular exercise, a relaxing bath, etc.).

4. Explain how the body "tells on" the heart and why Jesus says the two are so connected. In what ways do you see this principle play out in your own life?

5. What are some tangible ways you can minister to the physical body of another person?

6. How might we sacrificially use our bodies for God's glory rather than our own (Rom. 12:1)?

COMMUNITY AND RELATIONSHIPS

Missie Branch

Every day they devoted themselves to meeting
together in the temple, and broke bread
from house to house. They ate their food
with joyful and sincere hearts, praising God
and enjoying the favor of all the people.

—ACTS 2:46–47A

Introduction

Being born into a large family in an economically depressed community in the middle of a big city was one of the greatest gifts I was given in this life. Philadelphia is a city of neighborhoods. In mine, neighbors were considered family. My mother is one of six,

and I grew up surrounded by a plethora of grandparents, aunts, uncles, and cousins. My tight-knit neighborhood made me feel connected and responsible. I owe a debt to those adopted aunties and uncles, and "play cousins" that, along with my own fully invested family, helped me realize that the deficits that we faced did not define the direction of my life's race.

When my mom and her siblings became Christians, our already huge family expanded to include our newfound church family. I was surrounded and influenced by people from multiple generations, which was a treasure of incalculable worth. While I was not able to see it then, what we lacked in material things was more than made up for in the priceless discipleship passed to me by just being in the presence of people who loved Jesus. The community I was growing up in made me feel valuable and accountable.

Coming from these particular people in that particular place during that particular time taught me many things. I learned that who I am is inextricably connected to a bigger "we." My identity was being shaped in relationship to the world around me. I am both a product of my environment and a new creation in Christ, and that has been God's plan for me all along.

What the Bible Teaches about Community

Community can be defined as "a unified body of individuals with a common characteristic or interest."[31] In other words, there

[31] https://www.merriam-webster.com/dictionary/community

is a common unity. Ultimately, community is about God. It is a tangible expression of His personhood. For believers, God is both the commonality we share and the basis for our unity. God models it in the way that the Son is honored and beloved by both the Father and the Spirit: the Father is glorified by both the Son and the Spirit, and the Spirit binds the fellowship of the Son and the Father in love. He has always operated within a divine community called the Trinity. And since God is a community—one God, three persons—life together was the plan for His image bearers since the beginning. It can be seen clearly in Genesis 1, in the creation narrative, when He stated: "Let us make man in our image, according to our likeness" (v. 26). And again, in Genesis 2, when God saw that Adam alone couldn't experience intimacy like the Trinity, saying, "It is not good for the man to be alone" (v. 18).

We have been built to function in relationship. (Yes, even those of us who are introverts.) Relationality is an essential feature of what it means to be human, and God has made clear that we are better when we are connected with other people than we are in isolation (Gen. 2:18). Image bearers are designed to be relational because the Trinity is relational. Meaning, communities are at their best when each person is secure in their role, is committed to a common goal, and serves one another with grace and faithfulness.

Living in communal relationships is modeled for us from Genesis to Revelation. Through proximity, familiarity, transparency, and understanding, community is bred. The first human community we see in the Bible is a family—Adam, Eve, and their

children. And families continue to this day as foundational units of entire cities, regions, and countries. As we journey further in the pages of Scripture, we see that beyond just families, God chose another community, Israel, to commune with Him as a people—to be close to Him, to relate to Him, to understand Him. Israel was to be God's picture to the outside world of what it means to belong to Yahweh and to one another. There was so much good that was to come if Israel had stayed the course.

In the New Testament, God established the church as the most important type of community. No longer was community primarily established based on ethnic heritage or geographical location, but with the death and resurrection of Jesus, community is now based on adoption as sons and daughters. While this certainly applies to the universal church, God has also established local congregations in which we are to live life together, growing with one another toward Christian maturity.

The Power of Community

Community is a powerful tool. Even our culture understands this, as we can see in movies. Iron Man is great on his own, but saving the universe as we know it requires all the strengths of every single Avenger combined. Conversely, when villains like The Brotherhood of Mutants led by Magneto come together, sadly, they can take out the X-Men time and time again.

The Scriptures evidence the power of community as well. Through community the temple was built (1 Kings 5–7). The

roles of the stone layers, metal workers, and artisans were equally important because their temple would not have existed without all of their efforts. In Acts 2:42–47 we also see just how potent community can be as the believers dedicated themselves to the apostles' teaching and to one another, which drew in many new believers on a daily basis! Community is how the early church prospered and the disciples were supported, and it's how a paralyzed man was lowered through a roof just for a chance to be near to Jesus (Luke 5:18–25).

We can also appreciate the individual benefits of community when we read about relationships like David and Jonathan, Ruth and Naomi, Elijah and Elisha, Job and his friends, Mary and Elizabeth, and of course, Jesus and the disciples. In each of these cases, not just the community at large experiences something powerful but the individuals themselves! The tool of community forged these relationships through personal sacrifice, trust, support, humility, loss, service, integrity, belief, discipleship, and more. As each individual chose to commit to community, incredible victories were won for God's kingdom. And while the individual benefits are encouraging, the bigger lesson in each of these examples is that they are designed to be a blessing to the broader community as well.

Sorrowfully, community used the wrong way can also cause large-scale destruction. When we, being much like Israel, prefer to serve other masters and look like other communities, the results are disastrous. This can be seen in the story of the building of the tower of Babel (Gen. 11), the enslavement of God's people

by another group of people (Exod. 1), the desire for a king by the nation of Jehovah Shalom (1 Sam. 8), the arguing and divisiveness of the Pharisees and Sadducees, and the crucifixion of an innocent man.

On a smaller scale we can see how community done wrong can have devastating effects on individuals or families. Just look at Sarah and Hagar, Hannah and Peninnah, Joseph and his brothers, David and Uriah, and so many more. Unfortunately, the dysfunction and sin created in these relationships don't stay on the individual level long. They eventually have an effect on the broader community. Gratefully, Scripture also shows us how the Lord took even the worst of these situations and redeemed them. He promises to do the same for us: to take our mess and remake it for our good, for the good of our communities, and for the glory of His name.

Coloring our entire lives, the various communities we've belonged to at some point or another have helped make us who we are as women. Whether they have been healthy, fearful, secure, or lost, our relationships deeply affect the type of wife, mother, daughter, sister, or friend we are. As we look back over the various communities we've been a part of in the past, we can see that their presence in our live, has affected us for good. Other times, though, we see the painful scars they've left on us. Yet the discontentment, bitterness, loneliness, and resentment that come from being hurt do not have to be in vain. We serve a God who understands the emotional toll that living with broken people in a broken society can take. Being a masterful designer, He uses the

brokenness as a chisel to carve us into His image. At other times, it acts like a cattle prod, pressing us to see Him in the people and situations that have damaged us.

Common Areas of Struggle

When sin entered the world, it brought with it many devastating side effects, one of which is a gross fixation on our individual selves. We see this right away when God declares the consequences of Eve's sin: difficulty in her relationship with her husband and pain in bearing children (Gen. 3), as well as when Cain kills Abel over his offering (Gen. 4:8). As a result of our preoccupation with self, we are disinterested in a relationship with *El-Elyon* (the God Most High), producing competition when we are made for partnership and selfishness when we are designed for relationship. This sinful disposition is a struggle for all women in one way or another, and the worst part is that it even allows for a self-focused Christianity. Many times I find that women (myself included!) tend to promote a spirituality that is more concerned with *my* walk with Jesus, *my* devotions, *my* prayer time, and much less concerned with the needs, feelings, experiences, and even the salvation of the world around us. We forget that God has designed us for community. We forget that He calls us to be His hands and feet. We forget that He invites us to be His witnesses and disciple-makers. No matter where I go or whom I talk to, I've noticed that women far and wide struggle with self-fixation and need help

remembering how God designed us and whom He designed us to live alongside.

It's no wonder so many women struggle with this, for they have a great enemy who has been trying to ruin community from the start. Satan's first attack on the plan of *Elohim* was to divide the most important relationship: mankind and God. With that relationship fractured, the division flowed down into every other kind of relationship: husbands and wives, men and women, friends and their fellow loved ones, kids and parents, citizens and governments, church members and pastors; the list goes on and on. And to this day women often struggle in each of these relationships. Instead of feeling like their marriage is a healthy and strong community, they feel alone in it. Instead of enjoying friendships or church membership as a safe place to run and grow, they become a place to perform for the sake of saving face.

By destroying relationships and keeping us from enjoying God's plan for community, the enemy ensures we are malnourished socially, emotionally, and spiritually. This malnourishment causes us to reflect emaciated versions of a glorious God in whose image we were made but whose name and character we defame. Yes, all women will struggle with the temptations of the enemy to isolate themselves and defame God. But God is committed to relationships. So much, in fact, that when our relationship was severed with Him in the garden, He set in motion His plan to get it back.

The greatest of all communities is the church. The common goals of the church are first to *know God* intimately as the church

as a whole digs in and commits to cultivating a relationship with Him. Then, to *show God* to the surrounding community as we demonstrate our unity and serve as a lighthouse to the world in need of a Savior. When done right, the church should be the safest of all communities, the space where everyone has a role to play and a voice to be heard. Christian community should challenge us, encourage and protect us, motivate and inspire us. All of this is possible because of the intimate relationship we each share with *El-Roi* (the strong one who sees).

Yet often this is not the case, creating a struggle for women to connect to their local body of believers due to fear or past wounds. Sometimes the church isn't what it should be, and sometimes we end up hurt by the church in some way or another. Though many (including me) have been hurt in church by a pastor or fellow Christians, the communion of true brother and sister relationships is worth seeking. There is an undeniable connection between our spiritual lives and the richness of our community. We are not designed to grow spiritually while by ourselves. It is in the midst of our trials, hurts, and weariness that God can till the soil in our hearts, and spiritual maturity can be cultivated (Eph. 4:11–15). With maturity we recognize that when we are most damaged we must strive to safeguard a vibrant community life all the more.

I regret that I have had to watch the cause and effect of brokenness in my life and in the lives of those that touch mine. I have seen my own sin as the lives of others have become the mirror that reflects the pain I have caused them. I live in the tension of

knowing the effects of sin upon community, even among women. Women struggle with relationships with family members, particularly their husbands and children (so much so, that Paul instructs older women to train younger women to love their husbands and children!). Beyond that, friendships among women can be broken through selfishness and sin (again evidenced in Philippians 4:2 by Paul, who entreats two women in the church at Philippi "to agree in the Lord"). But I have also witnessed the incredible ways Jesus has changed lives through His inconceivable healing, lavish forgiveness, and unexplainable grace. This confirms my belief that God used my family through the years and now daily He is using my community to reconstruct me into His image makes me long to model selflessness in relationship and pursue unity with others until He returns.

Application to Ministry

The way we should apply the principle of community to our daily lives starts by remembering a few key things. First, living relationally is a gift. God has prescribed it for us in His Word. As we have seen, the need for relationships started in the garden with the relationship between God and Adam. Healthy Christian relationships are the fortune, the return on a shrewd investment. Pleading with us in his letter, John is driven by his passion for us to enjoy and embrace the fellowship he has experienced with the Lord Jesus Christ, his best friend, and other fellow believers (1 John 1:3–4). This camaraderie he describes is supernatural. It

is a gift. Through it we are developed in our faith and spurred on to do greater works to advance the gospel.

Various fears, particularly of being hurt, as we explored before, will tempt us to distrust God. So next, to build community in our daily life—both with God and with others—requires that we also remember that in Genesis we see that *God* is the initiator. He is invested in the relationship; He is empowering, kind, patient, long-suffering, compassionate, and merciful. Because of these things, we can trust Him! In Revelation, God is returning, reclaiming, and restoring that He might relate to us forever! First Corinthians 13:12 says, "For now we see only a reflection as in a mirror, but then face to face. Now I know in part, but then I will know fully, as I am fully known." Our earthly relationships are only capable of offering a dim picture of what Jesus looks like. This faded snapshot is designed to represent the hope of Christ's promised return and of our eventual eternal reign with Him.

Another thing we may need to remember while building community in our daily lives is this: while we look for support, refreshment, and accountability from our human relationships, our value and acceptance ultimately come from Christ. Our relationships will be most nourished when we remember that we were created in and approved by God and that our most primary relationship should be with Him. Christ is the treasure that is entirely satisfying and yet has you craving for more!

Our connectedness is vital. Remember, the purpose of community is to *know God* and then to relate to others while we *show God.* As we grow in knowing God and learning of His love for

us, only then can we properly show God's love to others. I once read that every day a spouse has the opportunity to be a visible manifestation of the love of Jesus to their husband or wife. The same is true for every woman who is born again: she is to be a visible manifestation of the love of Jesus to others in her community. Women can begin each day with intentionality, as they begin to consider tangible ways to display Christlike love. All that is needed to display such love is to consider who you are in relationship with, ways you can show them compassion and kindness, and a prayer for help from the Spirit to evidence the love that can only come from God.

Going further, each woman can be intentional in encouraging her sisters to love those within her community. Is there a woman you know who is isolated? Encourage her to become invested in the church, loving God through loving others. Alternatively, do you know a woman who has been hurt in the past by her church community? Sit with her and spend time actively demonstrating how we are to act within this community that God has given us. And lastly, love the community that God loves; foster affection and commitment to the body of Christ, the Church, so that others are encouraged by your example to do the same.

Philadelphia is a city of neighborhoods. But in Philly, the neighborhoods unite to cheer on our professional sports teams. Philadelphians are notorious for this. It is a time when many individuals are connected to a greater "we." My city, in all of its brokenness, is still able to produce a common unity even through something as simple as a football game. Christ is a far more

powerful unifier. In Him, there is a place for all of us. The church, made up of many smaller communities across the globe, comes together as we all cheer for the same King!

Discussion Questions

1. How have you seen God and the gift of His community in your life?

2. In what ways have you contributed to the flourishing of those in your community?

3. How has a focus on yourself affected your ability to cultivate relationships?

4. In what ways do you use your influence to encourage others to know God and to show God?

5. Recount a tough situation in your life. Can you see how God is able to redeem for His glory and for the good of your community? How are you able to see the value in the pain/hurt/confusion you experienced?

12

LOVING GOD AND
LOVING OTHERS

Kristin L. Kellen and Julia B. Higgins

God's love was revealed among us in this way: God
sent his one and only Son into the world so that we
might live through him. . . . Dear friends, if God
loved us in this way, we also must love one another.

—1 JOHN 4:9, 11

Introduction

In the first chapter we discussed the concept of biblical womanhood and offered a definition that does not find its primary location in the various *roles* of women or their *function*. Instead, we proposed that biblical womanhood begins with understanding the *nature* of a Christian woman: that she is created in the image

of God, she is fallen, she is redeemed, and she is being restored. These four core truths about a believing woman's nature give us insight into becoming a woman who honors God in the various roles and functions she fulfills throughout all of life. Thus, we concluded that a biblical woman is one who is created by God, whose fallen nature is redeemed by Christ, and who is being restored to love God with her whole heart, soul, mind, and strength and to love others as herself.

Chapter 2 helped us to orient our minds around the means toward becoming a woman who honors God by highlighting God as our authority since He is our Creator, Sustainer, Redeemer, and righteous Judge. Thus, it stands to reason that if God is our authority and He has given us His divinely inspired Word, then we are to submit to that Word as authoritative and as the rule and practice for all of life. Not only that, but since the Bible is authoritative, we should rely upon it daily, for it teaches us a correct view of God, of ourselves, and of others. Such reliance leads to life transformation so that we are able to love God with all our heart, soul, mind, and strength and to love others as ourselves.

In chapter 3, the overarching theme for the book was presented based on the two great commandments found in Mark 12:28–34. In that text, Jesus was tested by the Pharisees as one of the scribes sought to trick the Lord by asking him: "Which command is the most important of all?" Jesus' response provides a summary of the law and the prophets—the entirety of the Old Testament, and in reality, a summary of the Bible and all of life:

> "The most important is Listen, Israel! The Lord
> our God, the Lord is one. Love the Lord your
> God with all your heart, with all your soul, with
> all your mind, and with all your strength. The
> second is, Love your neighbor as yourself. There
> is no other command greater than these." (v. 28)

Therefore, the book has centered upon the concept of loving
God and others holistically, as we have been commanded to do.
Chapter 3 reminded us that a whole-person ministry focuses on
holistic well-being *in order to* propel the person toward holistic
love and worship. We love our neighbor more fully because it
helps her worship God better. It also brings her to the place of
loving her neighbor more fully, creating a domino effect as others
are impacted by this love.

The Great Commandment: Love God and Love Others

Pop culture often tells us that we must love ourselves. A quick
Google search on loving self brings up many inspirational quotes
about the importance of self-love. Most of these include some
form of the idea that you can't properly love others until you
know how to love yourself first. And it would even say that Jesus'
teaching underscores that we should love ourselves because He
said to love others *as we love ourselves*. The logic would then say we
should seek to love ourselves first. Yet that idea is not what Jesus
is teaching. He did not instruct us to love ourselves, but rather
to love others to the same degree and care that we already exhibit

toward our own selves. Assuming we seek to do what is best and good for us is a foregone conclusion.

Think about it—we can be inside no other head but our own from the moment we wake up to the moment we go to sleep. Though we certainly perform tasks that have to do with others, our typical default is to spend our mental energy thinking about ourselves—both in good and bad ways. We brush our teeth. We ponder what to wear. We think through our day and the best way to get through it for our own sanity and enjoyment. We consider what way we should construct a text or email to ensure we are taken the way we want to be. We play back scenarios in our head over and over, wondering how someone perceived our conversation with them. We consider what we will eat when we get hungry. We plan for our own physical maintenance. Even in the moments we serve a spouse, child, or friend, we sometimes do so for our own sense of accomplishment. Jesus' point is this: for better or worse, we already give a ton of attention and love to ourselves by default. What we really need to learn is how to give an equal amount of that energy to God and others. Therefore, the worldly wisdom that pushes us to spend time "learning how to love ourselves better" is to be rejected.

This section teaches the direct opposite of such worldly wisdom. We will consider loving God with all our heart, soul, mind, and strength, and loving others as ourselves.

Loving God

Loving the Lord our God can be a daunting command. How can we as selfish, prideful creatures truly and genuinely love this God who is totally other than us? How can we obey this instruction? We can only truly love God by understanding that He first loved us (1 John 4:19). Simon Kistemaker, writing on this verse in his commentary on 1 John, concludes: "Man can never claim that his love for God was prior to God's love for him. God always comes first in loving us, and we respond by loving him. Our love, then, is a copy of his love. He originates love and we follow his example."[32] So then, it is best to ask: "How has he loved us?"

He sent His beloved, perfect Son to die for us (John 3:16; Rom. 5:8). He takes people who were dead in their sins and, because of His great love, He makes us alive, saving us by His grace (Eph. 2:4–5). Once we have been saved by grace, our hearts are filled with God's love by the Spirit: "God's love has been poured out in our hearts through the Holy Spirit who was given to us" (Rom. 5:5). Reflecting on God's love, in turn, increases our love for Him. And we can also remember that Jesus prayed for us about this topic. He prayed that the love of the Father would be in His children (John 17:26). The apostle Paul also prayed for believers to know God's love in 2 Thessalonians 3:5, where he wrote to them: "May the Lord direct your hearts to God's love and Christ's endurance."

[32] Simon J. Kistemaker, *New Testament Commentary: James, Epistles of John, Peter, and Jude* (Grand Rapids, MI: Baker Books, 1996), 342.

If we meditate on God's demonstration of love toward us, have faith in the Spirit's gift of love in our hearts, rest in God's desire to answer the prayers of Jesus that we would have the love of the Father, and if we pray along with Paul that our hearts would be directed to God's love, we will find that our hearts, souls, minds, and strength are pointed toward loving God. Our desires, motivations, and emotions will begin to reflect a heart that loves God, and our relationship with the Lord, growing through the pursuit of spiritual disciplines, will increase our soul's love for God. Our minds will love God by thinking on truth and being sanctified by truth, as we study God for increasing our understanding of Him. And we will love God more completely through physical strength in our physical bodies, as well as in the spiritual body, His church, where we find community.

Loving Others

While loving the Lord our God with all our heart, soul, mind, and strength can seem daunting, the last section helped us see that those who are true believers have been given the ability by God's Spirit to love Him in response to His great love toward us. A love for God, specifically reflected in a love for Jesus, evidences that we have been made alive and that we are born again. Yet someone can claim to love God by expressing faith in or love for Jesus and still truly not know God. How do we know that we truly know God? First John 2:3–5 answers the question for us: "This is how we know that we know him: if we keep his commands. The one

who says, 'I have come to know him,' and yet doesn't keep his commands, is a liar, and the truth is not in him. But whoever keeps his word, truly in him the love of God is made complete." Jesus stated something to the same effect: "If you love me, you will keep my commands" (John 14:15). Therefore, a person who truly loves God will be marked by obedience to the Word of God. Additionally, 1 John 3 indicates that those who continue to practice sin and who do not love their brothers and sisters do not really know God (1 John 3:10).

So, how can we grow in loving others as we love ourselves? First, it is helpful to remember the biblical definition of love found in 1 Corinthians 13:4–8:

> Love is patient, love is kind. Love does not envy, is not boastful, is not arrogant, is not rude, is not self-seeking, is not irritable, and does not keep a record of wrongs. Love finds no joy in unrighteousness but rejoices in the truth. It bears all things, believes all things, hopes all things, endures all things.
>
> Love never ends.

Upon reading Paul's description of what love looks like, we are confronted with the self-sacrificial nature of love as well as the difficulty of maintaining such attitudes and actions toward others. But Jesus, an example of self-sacrificial love par excellence, is the one to whom we look for guidance on loving others. First John 3:16–18 reminds us about the love of Jesus and how it should transform our behavior:

This is how we have come to know love: He laid down his life for us. We should also lay down our lives for our brothers and sisters. If anyone has this world's goods and sees a fellow believer in need but withholds compassion from him—how does God's love reside in him? Little children, let us not love in word or speech, but in action and in truth.

Loving Others as a Tangible Demonstration of Loving God

Dear friends, let us love one another, because love is from God, and everyone who loves has been born of God and knows God. The one who does not love does not know God, because God is love. God's love was revealed among us in this way: God sent his one and only Son into the world so that we might live through him. Love consists in this: not that we loved God, but that he loved us and sent his Son to be the atoning sacrifice for our sins. Dear friends, if God loved us in this way, we also must love one another. (1 John 4:7–11)

In the same book, John tells us what it means to love God and others not just once, but many times. In fact, by the time John gets to this part of his first letter, he has already talked about love two other times. If you read straight through the book in

one sitting, it might almost begin to feel like a broken record. In chapter 2, love was seen as a demonstration of walking in the light (v. 10) and in chapter 3, we love because we are sons and daughters of God (vv. 17–18). But in chapter 4, John is getting at something important: our love for others is a tangible demonstration of our love for God, who is Himself love. As commentator Warren Wiersbe writes: "Love is part of the very being and nature of God. If we are united to God through faith in Christ, we share His nature. And since His nature is love, love is the test of the reality of our spiritual life."[33]

Did you catch that? Because God is love, if we do not love, He doesn't actually reside in us. Love in us is a marker of being a follower of Jesus. But understand that God's love isn't the love we think of; our understanding of love is marred by sin. Instead, His love is pure, holy, and perfect.

John writes this clearly in verse 7 but echoes it in verse 8 by putting it in the negative: if we fail to love others, then ultimately we fail to know God. If our nature is aligned with His, our action and disposition will be also. We cannot act contrary to our own nature; if our nature has been redeemed by God, His Spirit in us conforms us to love as He loves. If our nature is still broken and enslaved to sin, we cannot love as He does. Or, as Jesus put it in Matthew 7:18 (ESV): "A healthy tree cannot bear bad fruit, nor can a diseased tree bear good fruit." The fruit of our life shows whether we are a good tree or a bad one. Bad trees—those that

[33] Warren Wiersbe, *The Bible Exposition Commentary: New Testament: Ephesians-Revelation*, vol. 11 (Colorado Springs: David C. Cook, 2008), 515.

do not have a transformed nature—can't bear good fruit. And likewise, good trees—those that have been transformed in nature by Christ—cannot bear bad fruit! A tree will bear fruit according to its nature.

John continues in verse 9 with what is the most important truth we could glean from this passage: what true love looks like. It is a point so important that verse 10 echoes the same truth. John reminds us that God showed His love through Christ's death on the cross. The sacrifice of His Son was the most pure, holy, and perfect demonstration of love there could ever be, that a holy God would empty Himself and become like us, humbling Himself even to the point of death on a cross (Phil. 2:7–8). And Jesus Christ did this while we were still sinners (Rom. 5:8), far off from Him. Yes, Christ came for the bad trees whose nature and fruit were rotten!

And note this statement in verse 9: *"that we might live through him."* Jesus Christ came to give us life and give it abundantly (John 10:10)—and not just in the life to come but in the here and now. God loved us so much that He desires that we live our fullest life here on earth—but a full life by His measure, not our own. He is the Vine, and when we connect to Him by grace through faith, we transform from dead plants to living ones—and not merely any sort of living plant but *good* ones with a new nature that can bear much fruit (John 15:1–5)!

In the echoing statement in 1 John 4:10, John adds the statement that God "sent his Son to be the atoning sacrifice for our sins." Do you know what *atonement* means? That's one of those

"church words" we hear a lot but oftentimes we don't really know what it means. *Atonement* means "reparation or amends." In biblical terms, it means that the price has been paid for our sin so that we can be reconciled to God. In Christ's death on the cross, we can be reconciled to God; our sin has been atoned for. At the cross God was both just and merciful. The price for our sin was paid in full, and we can be restored to a right relationship with Him.

Finally, in verse 11, John brings it all together for us. He reminds us that "if God loved us in this way, we also must love one another." In other words, since God did all of this on our behalf (sent His Son to reconcile us to Himself, as a perfect act of love), we *must* respond in kind. There is no option to do otherwise. As followers of God, as His children, it is to be in our nature to love God and, therefore, love others. We are connected to the Vine—to the life-giver. And as His vitality flows to us, we become life-givers, too.

This book has walked through in depth what it means to love others, based on the assumption that you, friend, love God. But I would encourage you at this moment to evaluate that reality. Have you committed yourself to loving God and obeying Him in this way? Are you in a *relationship* with God, going beyond simply knowing the right answers? If you are not, please do not delay. It is impossible to love others, impossible to do what we've laid out for you in this book, if you do not first love God. But if you do, loving others will flow naturally because your nature will now be like His. If you find that you're not loving the fruit your

life is bearing, perhaps it may be time to ask Jesus to make you a different sort of tree!

Bringing Everything Together: Putting a Ministry to the Whole Woman into Practice

By this point in the book, you've read a lot: what the Bible has to say about ministering to our sisters and brothers, some common areas of struggle in each sphere of life, and some practical ways to apply what you've read. Let me take a brief moment, though, to leave you with four steps to immediately put into practice what you've learned.

Step 1: Commit to Loving Others Holistically

We've all made New Year's resolutions. And likely we've all failed at keeping them as well. But the most important part of making a resolution is an actual commitment to change. Without that commitment you simply have a "well that'd be nice" type of thought. But that gets us nowhere.

The first step to ministering to women holistically is to commit to do so. Commit to yourself, and someone else if possible, that you will aim to serve your sisters in all spheres of life, even when it doesn't feel natural or doesn't come easily. Commit to seeing other people as multifaceted and unique; service to them should mirror that uniqueness.

More specifically, make a point to regularly think about who in your life you could minister to in this way. Are you a part of a

small-group Bible study? Or do you have one or two close friends you do life with? Start there! Consider a small handful of people and commit to love them as holistically as possible.

Step 2: Be Aware of Needs

After making a commitment to serve others more fully, and identifying those you can serve, consider the needs they may have. At first thought, in what areas of life might that woman be struggling? What has she expressed outright that her needs are?

As you work toward developing an awareness of needs, it may require a direct conversation. Ask her the areas she is struggling in and where her greatest needs are. Explore all eight of the arenas we've walked through in this text, perhaps using some of the discussion questions as fuel for conversation. Then write down her answers for future reference.

As a side note here, the exercise of becoming aware of the needs of another may reveal areas of need in yourself. Don't neglect those. You may have already begun identifying areas in which you are lacking and need help, but conversations and exercises in serving others may well expose areas of need in your own life as well.

Step 3: Seek to Meet Those Needs

This next step is much easier to say than to put into practice: seek to meet the needs you've identified. Do what you can to serve another woman in the way you or she has identified, doing so in direct and intentional ways.

What might this look like? For example, let's say a friend shares that she's struggling with her study of God's Word. One way you can minister to her is through a one-on-one Bible study or through finding resources for her to read. Or you could help her talk through the questions she has, answering any you can, then referring her to someone else who could talk.

As another example, you might notice in another friend that her emotions seem to be a struggle for her. She may seem withdrawn and down, unable to shake feelings of hopelessness or worry. One way to minister to her is to help her find a counselor who can work through troublesome feelings, but you can actively encourage her often. Call and see how she's doing or drop by with a cup of coffee. Let her know that you are thinking of her and care for her.

In a final example, perhaps your friend or family member isn't taking care of herself physically and could use some help to value her body the way God values it. Maybe you could help her create a nutrition plan (or connect her to a nutritionist you know if this is not your expertise), try a meal-planning system together, go to the doctor with her if she is scared about a certain ailment, or hit the gym with her on the days she is struggling to find motivation.

Notice in each of these examples that you don't have to shoulder this type of ministry alone! In many cases someone else was brought in to help when needed. Just as we all have different areas of need, we also have areas of strength and areas of weakness. We can't all be good at everything; that's where community comes in.

Step 4: Teach Others to Do the Same

Over and over in the Bible, we see the theme of making disciples who make disciples; Jesus did it, Paul did it, and we should do the same. Ministering to other women holistically is something we can all participate in, even if we do have areas that come more naturally to us. But the awareness of all of the different spheres of a woman's life isn't something most of us consider often. Think about it—how aware were you of all of these areas of need before reading this book? We as women need people to teach us, but now you are equipped to do some of that teaching!

Paul writes in 2 Corinthians 1:4: "He comforts us in all our affliction, so that we may be able to comfort those who are in any kind of affliction, through the comfort we ourselves receive from God." God's comfort to us is holistic; He cares for our hearts, souls, minds, and strength. He never fails to meet any need we have. But when He meets our needs (comforts us), it's not just for us. Notice what Paul says here: *"so that we may be able to comfort others."* God meets our needs so that we can meet the needs of others.

One way we do that is through whole-person ministry. Whether it's in the form of evangelization, emotional support, helping someone study the Bible, or physical care, we evaluate what our sister needs, and we seek to meet those needs as best we can, bringing in help when we need it. Then, as we minister to other women, we teach them how to do the same thing, replicating what we are doing. In other words, we're making disciples who make disciples. We're doing what Jesus did.

Final Thoughts: Establishing a Whole Woman Ministry in Your Church

Whether you are a part of a small congregation or a booming, multisite church, you can put this into practice in a couple of easy ways:

Begin a Bible study and read through this book together. Gather women of like mind and heart and commit to doing this type of ministry together as a group. You can each pick a few ladies to focus on inside or outside of the group, but provide accountability for one another.

Make a list of one or two women to be intentional in serving. Write their names someplace that you will see them daily. Pray for them often, that the Lord will reveal where their needs lie and that you will have opportunities to serve them in various areas of their lives.

Write out your own areas of need and commit to transparency with another woman. Work through each of the eight areas we've explored in this book, writing out any needs you have in each area. Share with a woman you trust. Invite her to share her own areas of need.

Establish ministry teams for each of these four areas. Choose a few women who are gifted in each of the four main arenas (heart, soul, mind, and strength), appointing them to think through and implement ways of serving women in that arena in particular. Regularly rotate members of each group for a fresh perspective.

In conclusion, it is our hope that you walk away from reading this book both encouraged and challenged. You, friend, are a multifaceted, unique image bearer of the Most High God, and you

are loved by Him! So loved, in fact, that He sent His Son to die in your place. He calls us, in response, to love one another fully. Just as we love Him with our heart, soul, mind, and strength, so should we love others the same.

ABOUT THE AUTHORS

General Editors

Kristin L. Kellen (MA, EdD, PhD) is assistant professor of biblical counseling at Southeastern Baptist Theological Seminary. Her focus is counseling children, teens, and their families. Kristin is the coauthor of *The Gospel for Disordered Lives*. Kristin and her husband Josh have three children.

Julia B. Higgins (MDiv, PhD) is assistant professor of ministry to women and associate dean of Graduate Program Administration at Southeastern Baptist Theological Seminary. She teaches in the Ministry to Women degree programs at Southeastern, with her ministry focus being college-aged and adult women. She is married to Tony, who serves as executive director and staff counselor at Bridgehaven Counseling Associates. They live in the Raleigh Duram area and worship at The Summit Church.

Contributors

Missie Branch is the assistant dean of students to women at Southeastern Baptist Theological Seminary and is focused on

discipling and equipping women for ministry. Missie and her husband, William, were church planters for eight years in Philadelphia before moving to Wake Forest, North Carolina.

Emily Dean (MDiv, PhD) serves as assistant professor of ministry to women at New Orleans Baptist Theological Seminary (NOBTS) and Leavell College. She and her husband, Jody, along with their two children, live in the New Orleans area where Jody serves as senior associate regional dean for Extension Centers and associate professor at NOBTS. Emily's ministry focus is preparing women for ministry leadership.

Tara Dew (ME, EdD) serves in ministry alongside her husband, Jamie, president of New Orleans Baptist Theological Seminary (NOBTS). She is the mother of four children and has been a pastor's wife for more than twenty years. Tara's ministry focus is training and equipping women for ministry, particularly ministry wives. She teaches adjunctively and directs *Thrive: A Minister's Wife Certificate Program* at NOBTS.

Lesley Hildreth (MA) is the women's discipleship director at The Summit Church. Lesley and her husband, Scott, served eight years overseas with the International Mission Board (IMB) before coming back to the States to work in full-time ministry and education. She is a frequent contributor to the IMB and has written for Lifeway, Baptist Press, *Biblical Recorder*, Southeastern Baptist Theological Seminary, and other online resources.

Kelly King (MTS) is the manager of Magazines/Devotional Publishing and Women's Ministry Training for Lifeway Christian Resources. She is the author of *Ministry to Women: The Essential Guide to Leading Women in the Local Church and* the Bible study *Living by Faith: Women Who Trusted God.* She has also contributed to Lifeway's Advent and Easter studies and is the cohost of the Lifeway Women's *Marked* podcast. Prior to coming to Lifeway, she served as the Women's Missions and Ministries Specialist for Oklahoma Baptists and taught women's ministry courses at Oklahoma Baptist University. She holds a Master of Theology degree from Gateway Seminary in Ontario, California, and is currently pursuing her Doctor of Ministry degree.

Christy Thornton (MA, PhD) is the director of the ThM program, and associate director of PhD studies at Southeastern Baptist Theological Seminary (SEBTS). She completed a PhD in systematic theology in which she has focused on Trinitarian, Christocentric Dogmatics. She teaches adjunctively at SEBTS and is a member of The Summit Church.

Amy Whitfield (MA) is executive director of communications at The Summit Church. She is cohost of the podcast *SBC This Week* and has served in various professional capacities for the Southern Baptist Convention for more than twenty years. Amy coauthored the book *SBC FAQs: A Ready Reference*, and in 2019 she helped launch the SBC Women's Leadership Network. She is married to Keith, who serves as provost at Southeastern Baptist Theological Seminary. They have two children and live in Wake Forest, North Carolina.